IMAGES
of America

A&P
THE STORY OF THE GREAT ATLANTIC & PACIFIC TEA COMPANY

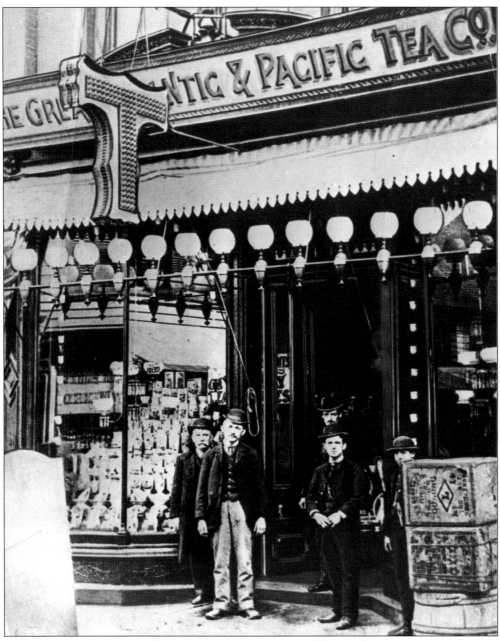

This early-1880s A&P storefront is, in many ways, quite different from more modern stores. (Courtesy the Hartford Family Foundation.)

IMAGES
of America

A&P
THE STORY OF THE GREAT ATLANTIC & PACIFIC TEA COMPANY

Avis H. Anderson

ARCADIA

Published by Arcadia Publishing,
an imprint of Tempus Publishing, Inc.
2A Cumberland Street
Charleston, SC 29401

Printed in Great Britain.

Library of Congress Catalog Card Number: 2002103222

For all general information contact Arcadia Publishing at:
Telephone 843-853-2070
Fax 843-853-0044
E-Mail sales@arcadiapublishing.com

For customer service and orders:
Toll-Free 1-888-313-2665
Visit us on the internet at http://www.arcadiapublishing.com

This book is dedicated to Olivia Wrightson Switz, founder and first president of the Hartford Family Foundation. In gratitude to her forebears, she is devoting her later life to preserving their memories and the memory of the company they founded. Her inspiration and gift to her family's younger generations will continue on for many years to come.

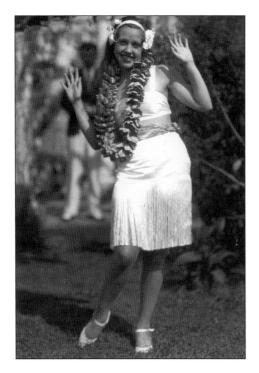

Olivia Wrightson Switz appears in a Hawaiian costume at a dance performance in 1928. (Courtesy the Hartford Family Foundation.)

CONTENTS

ACKNOWLEDGMENTS

This book, like most historical collections, was accomplished with the assistance and support of many people.

For more than 20 years, members of the Hartford Family Foundation have contributed photographs to the Hartford Archives for preservation. The foundation's collection of store images, advertising samples, and family photographs continues to provide information about the past and serves as a reminder of company and personal achievements. Originals are professionally stored for exhibition use, and image copies are part of a large database used for reproduction purposes. Without the use of this collection, a book on the history of the Great Atlantic & Pacific Tea Company would not have been possible.

I would like to thank the president of the Hartford Family Foundation, Jeffrey G. Wrightson, for giving the book a final read, and Grace Wrightson, member of the board of trustees, for her kind words and support. A special note of thanks must also go to Paul and Karen Stillwell, whose many years of collecting A&P memorabilia contributed greatly to this publication.

At the A&P corporate headquarters in Montvale, New Jersey, I received invaluable assistance from Richard De Santa, vice president, corporate affairs; Patti Councill, communications manager; and Craig Grybowski, who along with his position in real estate research, serves as president of the A&P Historical Society. Richard, Patti, and Craig contributed materials and editing skills to this project. Historical society member and Super Fresh employee Walt Waholek also provided materials from his personal collection.

Last but not least, my thanks go to Stan Cain, who provides me with his graphic design expertise, scanning capabilities, time, and above all, his total enthusiasm for any project I undertake.

This book is a tribute to George Huntington Hartford, his founding principles, and the visionary men who kept and continue to keep the Great Atlantic & Pacific Tea Company in the forefront of American business.

INTRODUCTION

In the 20 years I have been directing the activities of the Hartford Family Foundation, the subject of a book has been discussed many times. The collected photographs of A&P's rich history and the founding family's lives tell a fascinating story of entrepreneurship, business acumen, wealth, and philanthropy.

The story of A&P's progress is an educational and sentimental journey from the days of personal service and horse-driven wagons to modern stores offering the widest array of products. The photographs included in this volume take you into the stores, into the lives of the founding family, and into the hearts of customers who have been loyal to A&P for more than 140 years.

A&P's phenomenal success was based on a simple philosophy of business practice: providing customers with the best-quality product at the lowest possible cost. It was an idea that took off—and it took off big. At its peak, A&P operated more than 15,000 stores. The name A&P at one time was synonymous with the term grocery store for many American families. As the company continues today under the name A&P and several other store banners, the principle that made it great continues to attract new customers.

—Avis H. Anderson
Executive Director of the
Hartford Family Foundation

FOREWORD

It gives me great pleasure to welcome you to this beautifully illustrated account of the history of the Great Atlantic & Pacific Tea Company.

As the people of A&P responsible for writing the next successful chapter in this great company's history, we are proud to be the beneficiaries and custodians of a legacy that is unparalleled in North American commerce.

It was vision that compelled our company's founder to set this remarkable story in motion in 1859 and inspired his sons to take their concept literally across this land, several times reinventing it in concert with changes that redefined the nation, the marketplace, and the consumer.

And so today, we too are guided by a vision, one that is contemporary yet rooted in a set of core values that mirror those embraced by the Hartfords. *Guard Our Good Will* was the title of a handbook they distributed for many years to new associates, communicating the unwavering honesty and respect that was to guide them in working together, serving their customers, and enhancing their communities.

We are mindful of that good will and of the special place in North American life forged by our predecessors as we work to ensure that the future of A&P and its family of companies is as rich as its past.

—Christian Haub
Chairman of the Board and
Chief Executive Officer

One
THE EARLY YEARS

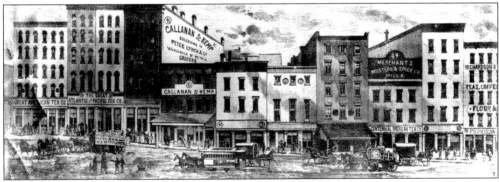

In the United States in the late 1850s, Americans were disagreeing over the issue of slavery and heading toward the Civil War, and Abraham Lincoln was running for his first term as president. In lower Manhattan, the Great Atlantic & Pacific Tea Company began as a mail-order business called the Great American Tea Company. George F. Gilman, a native of Waterville, Maine, was the son of a wealthy shipowner and leather merchant. Legend has it that young George Huntington Hartford, also born and raised in Maine, met Gilman in St. Louis and began working for him. The two men returned to New York and became fascinated by the clipper ships with their cargos of high-priced tea. Seeing an opportunity to eliminate the middlemen, the two men began selling tea at cut-rate prices right from the dock. Eventually, they bought whole cargos of tea, and a permanent location for a storefront was sought. The first store-warehouse operation was located at 31 Vesey Street in 1859. This drawing shows the location amidst the other tea and food purveyors of the time. (Courtesy the Hartford Family Foundation.)

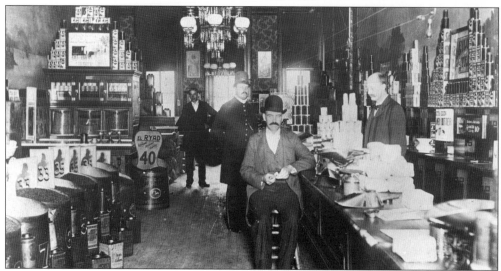

The early stores were described as resplendent emporiums. A large sign in the shape of a capital letter T was hung above the door and emblazoned with dozens of small gaslights. The store was painted in vermilion and gold leaf imported from China. Through the large front windows, potential customers could see crystal chandeliers and curved arches of gas jets. The walls were decorated with gilt-edged Chinese panels. The ceilings were made of fancy tinwork, and the cashier's station was shaped like a Chinese pagoda. In the center of the main floor, a cockatoo on a stand welcomed the trade. Early product boxes and tins also featured pictures of cockatoos. (Courtesy the A&P Historical Society.)

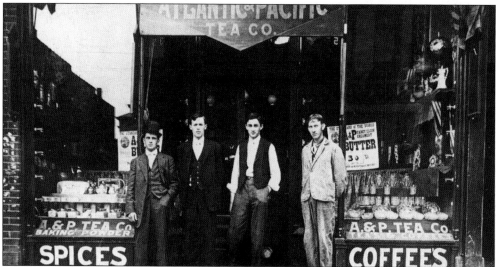

As the railroads began to tie the east and Midwest more closely together, farmers and industrial workers began pouring westward, and A&P moved with them. In 1871, the great Chicago fire took A&P to the heart of the Midwest. The fast-growing city of poorly built wooden structures was a smoldering ruin, and the country mobilized its resources to come to the aid of the devastated city. A&P food was among the first shipments of relief supplies that had begun to arrive. An A&P store was hastily established, and within a few months, there were two more. As the thriving community rebuilt itself, A&P stayed in Chicago and opened many more retail outlets. (Courtesy the A&P Historical Society.)

Great American soon developed a "club plan" to encourage people to place orders together. Early advertisements promoted the club plan to people outside New York, and the free gift to the person who formed the club was incentive enough for hundreds of clubs to be formed by the end of 1866. (Courtesy the Hartford Family Foundation.)

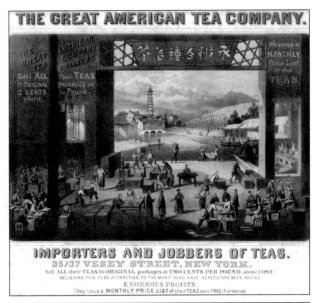

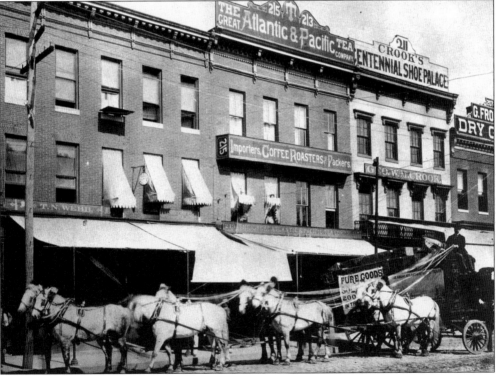

In 1870, the Great American Tea Company was renamed the Great Atlantic & Pacific Tea Company in honor of the first transcontinental railroad. The driving of the stake at Promontory, Utah, in 1869, linking America's two coasts, opened up a whole new era of transportation and distribution of products. At that time, A&P operated 11 stores selling tea, coffee, sugar, and baking powder. The Great American Tea Company name was retained, with that business selling company products through mail order and wagon routes in 30 states. (Courtesy the Hartford Family Foundation.)

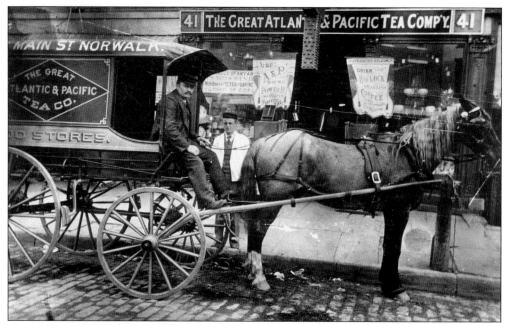

The photographs on this page feature early storefronts with the letter T sign and gaslights framing the store entrance. Pictured in 1892, this store was located at 41 Springfield Avenue in Newark, New Jersey. The driver bears a strong resemblance to George Ludlum Hartford, but there is no record of Hartford making wagon deliveries to stores. (Courtesy the A&P Historical Society.)

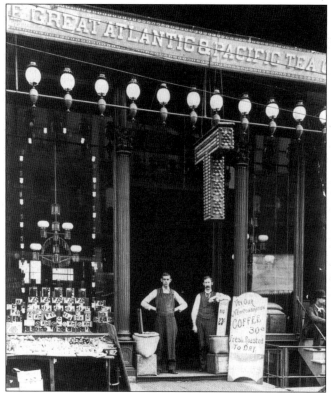

This picture, also from the late 1800s, offers a better view of the large letter T above the door and the elaborate gas lamps inside. The store's crystal chandeliers featured gas jets with curved arches and globes of patriotic red, white, and blue. The men and store location are not identified. (Courtesy the Hartford Family Foundation.)

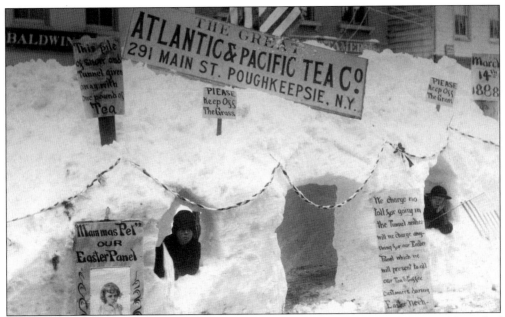

The A&P at 291 Main Street in Poughkeepsie, New York, is shown after the Great Blizzard of March 1888. Offices and shops were closed, supplies dwindled to dangerous lows, and walking in deep snow caused many deaths by exhaustion. Note that this igloo-like entrance did not fail to advertise that week's premium store calendar available inside. (Courtesy the A&P Historical Society.)

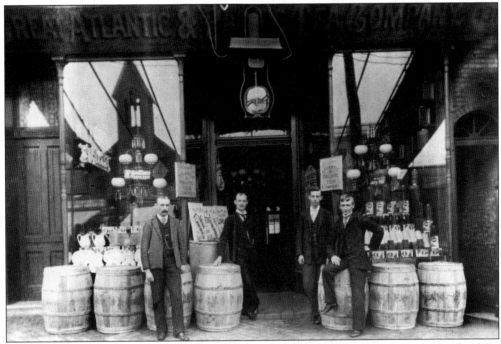

This 1895 photograph was taken in front of the A&P at 431 Broadway in Baltimore, Maryland. By this time, there were also A&P stores at 27 West Baltimore Street, 41 North Eutaw Street, 231 North Gay Street, and 136 South Broadway in Baltimore. (Courtesy the A&P Historical Society.)

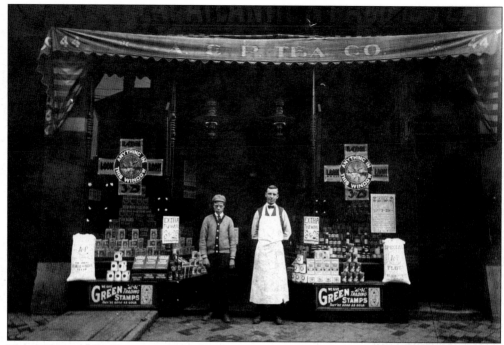

These photographs show exterior and interior views of the store at 710 Warrington Avenue in Pittsburgh, Pennsylvania, in 1911. The store manager (above in the apron and below behind the counter) is James O. Johnston. The boy and woman in the photographs are not identified. (Courtesy the A&P Historical Society.)

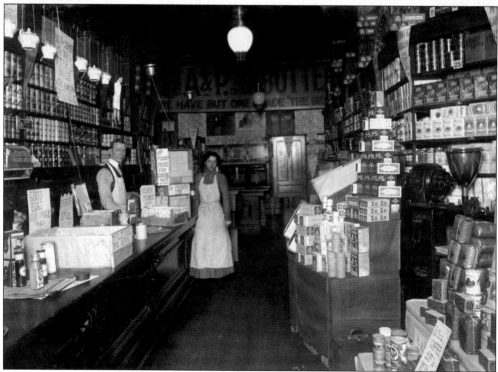

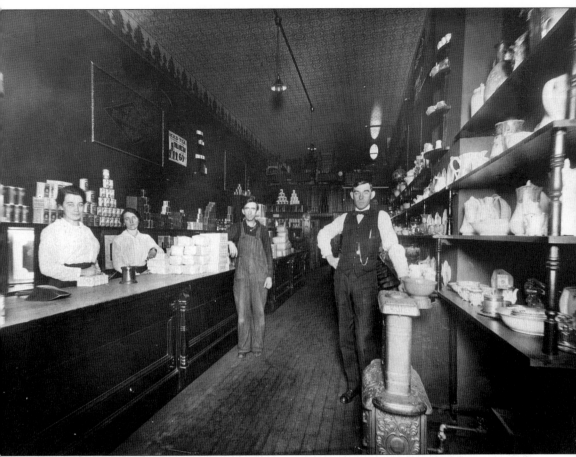

A&P attributes much of its early popularity to the practice of giving away coupons to be redeemed for premium gifts in all their stores and on all their wagon routes. From trade cards and lithographs, premiums evolved to china and glassware. Shelves were stocked with fancy crockery, japanned tea trays, and chromos of genuine oil paintings. Many editions of the *Little Bright Eyes Storybook* were obtained by mothers who bought tea, coffee, vanilla extract, and spices. By 1900, the value of A&P premiums equaled half its total investment in business and more than three times its annual profit. Pictured with its proud display of premium items is the A&P store in DuBois, Pennsylvania. The employees are, from left to right, Grace Ray, bookkeeper; Della Hewitt, clerk; Cy Winston, clerk; and B.A. Booth, store manager. (Courtesy the Hartford Family Foundation.)

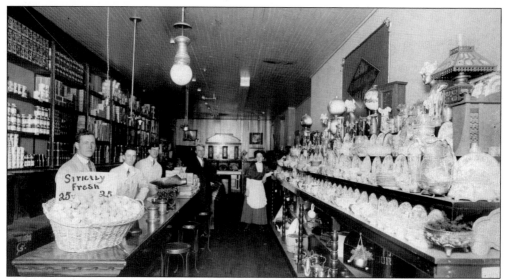

This A&P store looks more like a gift shop than a grocery store with the abundance of premium items on its shelves. (Photograph by Bolter Brothers; courtesy the A&P Historical Society.)

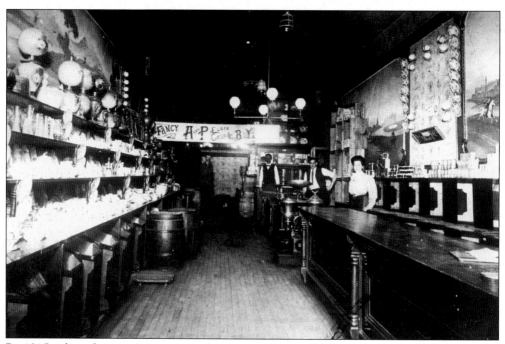

By 1915, when the premium program began to fade, the A&P catalog boasted more than 60 pages of items that could be obtained from saving coupon checks. For example, if you purchased a 50¢ can of baking powder, you received 10 checks. If you purchased a 30¢ pound of Sultana coffee, you received two checks. A mission oak rocker could be obtained by redeeming 160 checks, a baby's high chair for 67 checks, and a cut-glass cream and sugar set for 133 checks. The store shown in this 1903 photograph was located in DuBois, Pennsylvania. The staff includes, from left to right, Harry Haugh, manager; J. Coats, clerk; and Grace Ray, bookkeeper. (Courtesy the A&P Historical Society.)

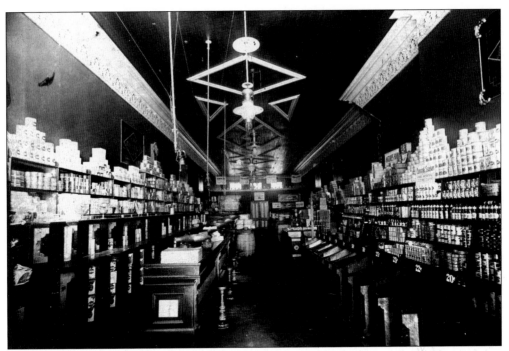

A&P operated nearly 200 stores by 1900 and had annual sales of $5.6 million. The company also expanded its line of merchandise to include cocoa, butter, flour, and several canned grocery items, along with its mainstays of tea, coffee, spices, and baking powder. Prices were substantially lower than many, if not most, of its competitors. All A&P stores provided credit and delivery services—common practices in those days. These photographs show stores of the early 1900s with their more diversified product lines. The store above was located on Union Street in Nashville, Tennessee. The location of the store below is not identified. (Courtesy the A&P Historical Society.)

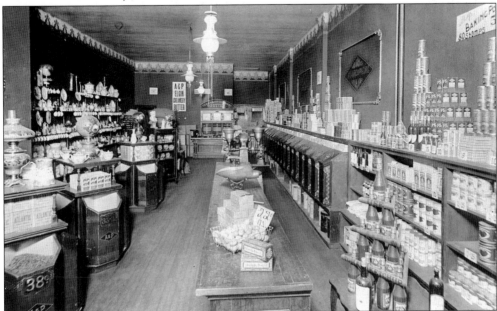

By 1912, A&P management decided to make some changes. Young John Hartford realized that the attention given to premiums and giveaways had been key to A&P's early retail success. Since then, however, company stores numbered 450 and sales had tripled, making premiums expensive frills. After much debate with his father and brother, John Hartford opened his first A&P Economy Store at 794 West Side Avenue in Jersey City, New Jersey. The cash-and-carry

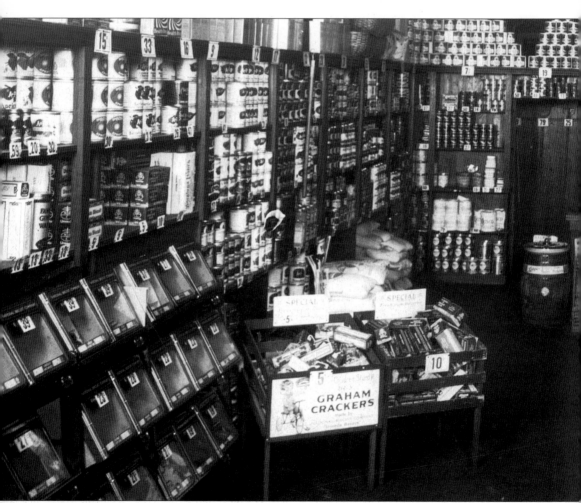

The fixtures in the 20- by 30-foot A&P Economy Store included basic shelving, a small ice refrigerator, and a simple sign stating, "A&P Economy Store." The whole operation—from shelving to inventory and cash on hand—amounted to an investment of less than $2,500. Gross profit was set at 15 to 19 percent, compared to 25 to 30 percent in the regular A&P

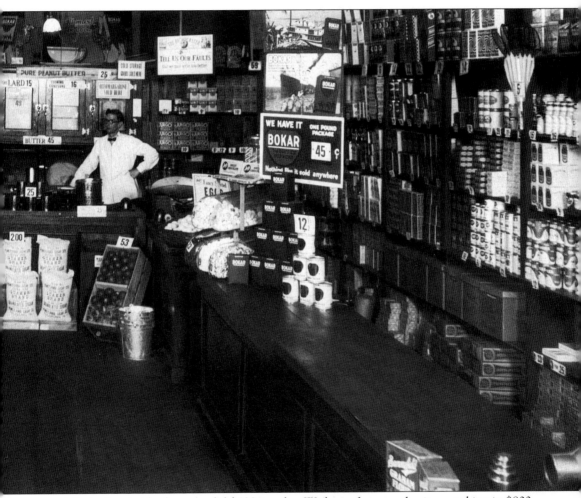

store had plain furnishings and fixtures and offered no credit, delivery, or premiums. It simply featured quality groceries at very low prices. Within six months of opening, the A&P Economy Store forced the conventional A&P store nearby out of business. (Photograph by Jeff Martin; courtesy the Hartford Family Foundation.)

stores. In its first week, the store did $400 in sales. Within a few months, it was taking in $800 a week and turning a nice profit. The unidentified store in this photograph was typical of the average A&P Economy Store. (Courtesy the Hartford Family Foundation.)

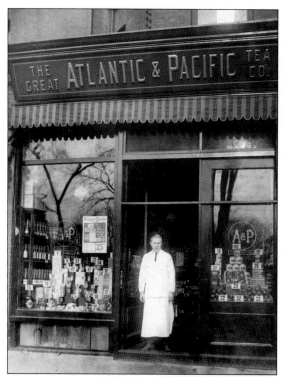

The A&P Economy Store movement was fast and furious. A&P began opening these stores by the thousands. This Boston store is shown with manager James Mason Logee in November 1922. In 1915, in the Boston area alone, the company opened 95 A&P Economy Stores in six months. By February 1915, 554 economy units had been opened nationwide less than two years after John Hartford had opened his first store. In 1916, the company announced that it had more than 2,000 stores in 29 states. In 1917 alone, it added 1,000 more. Sales volume boomed from $13 million in 1910 to $76 million in 1916. (Courtesy the A&P Historical Society.)

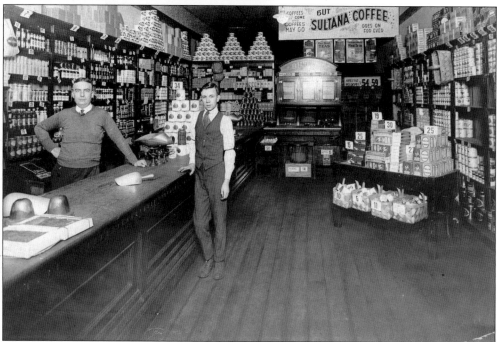

The small quarters of the average A&P Economy Store did not require a large staff. One or two employees could adequately handle the daily customers. The average salary of the A&P Economy Store's employee was $12 or $13 a week plus one percent of sales exceeding $200. (Courtesy the A&P Historical Society.)

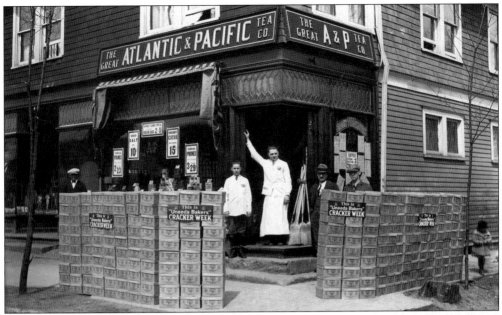

This A&P store took advantage of its corner location to create a sidewalk display promoting Uneeda Biscuits. Street crime was not much of a problem in this Pennsylvania town. The employees are unidentified. (Photograph by A.F. Clifford, National Biscuit Company; courtesy the Hartford Family Foundation.)

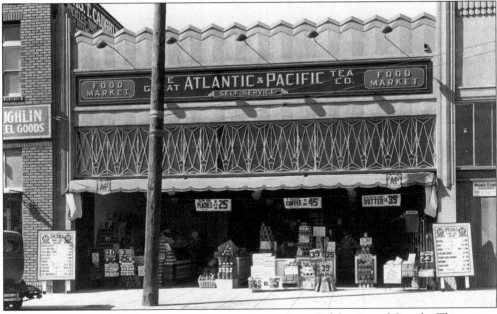

In the early 1930s, A&P began opening stores in southern California and Seattle. This sunny, open-front A&P store was located in Long Beach, California, in the 1930s. At one time, the company operated more than 100 stores in the Los Angeles area. The West Coast stores never produced the volume of the stores in the other parts of the country, and by the end of the 1960s, A&P sold all its stores in California. (Photograph by Winstead Brothers; courtesy the Hartford Family Foundation.)

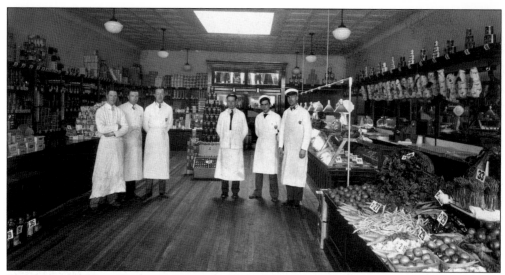

The National Meat Department was established by A&P in 1926. This gave birth to the combination store, which provided customers with all the basic food commodities under one roof. A&P had previously experimented with meat and produce in a few stores, but it was not until both the meat and produce divisions were added that the combination store became a standard fixture in American food retailing. This Winchendon, Massachusetts A&P combination store had a staff of six employees in 1930. The workers are, from left to right, Emerson White, clerk; Ted Nichols, clerk; Ernest Noel, store manager; Tom Carey, clerk; Matthew Quinn, meat cutter; and Andrew Butland, meat manager. (Courtesy the Hartford Family Foundation.)

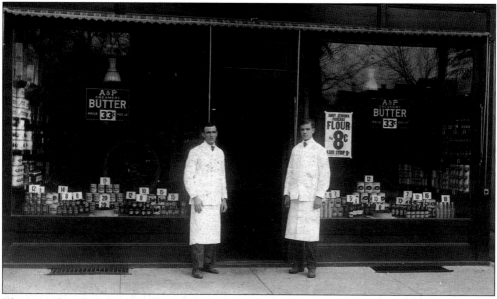

These unidentified A&P employees are immaculately dressed in their ties and starched white aprons. Cleanliness and appearance were stressed in all employee publications sent out by headquarters. A manager's manual on produce sales techniques included this advice: "Eight Checks to Help You Please Customers: 1. Hair combed 2. Hands and fingernails clean 3. Shirt clean 4. Necktie neatly tied 5. A friendly smile 6. Trousers pressed 7. Smock clean 8. Posture erect." (Courtesy the A&P Historical Society.)

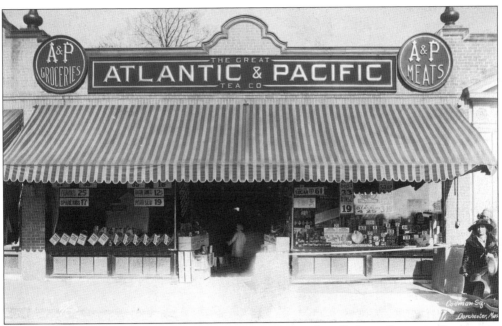

The store above is an early A&P combination store. Located on Codman Square in Dorchester, Massachusetts, it was one of the earliest stores to include a butcher department. This photograph was taken on April 18, 1927. The A&P store below was located at 1903 West Cumberland Avenue in Knoxville, Tennessee and was photographed in 1930. (Courtesy the A&P Historical Society.)

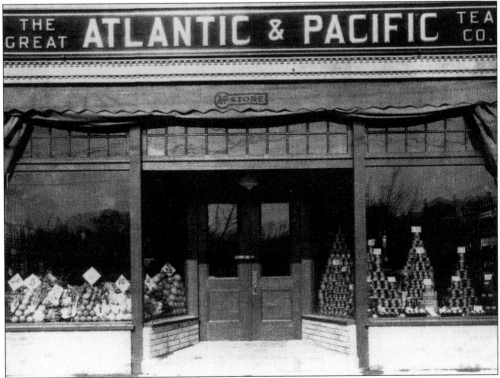

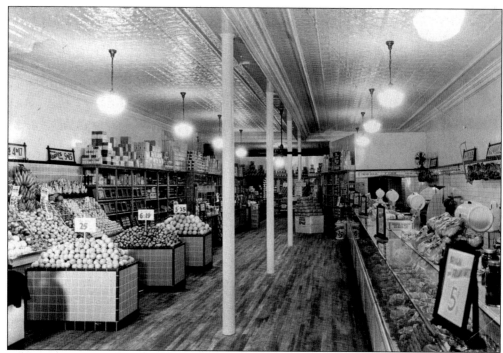

These two interior photographs were taken on the opening day of a combination store at 9-11 West Michigan Avenue in Battle Creek, Michigan. In April 1933, when the picture was taken, the manager of the store was Burl Burnham. The more diversified product offerings of the combination stores built volume and offered greater customer shopping convenience. (Courtesy the Hartford Family Foundation.)

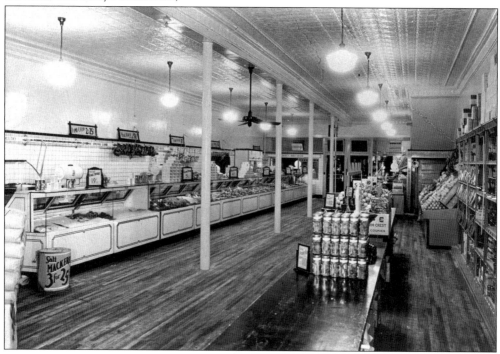

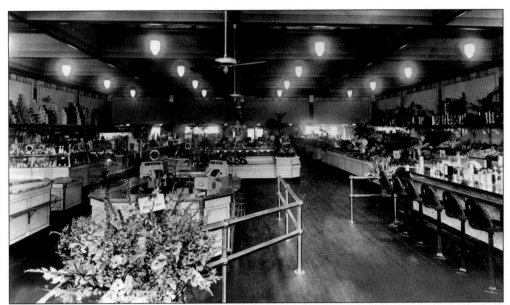

This elaborate store, shown c. 1930, was located in Grand Rapids, Michigan. The skylights, fresh flowers, and art deco counter stools created an atmosphere of an upscale food market of today. Better merchandising techniques through special displays and attractive promotions were stressed throughout the 1920s in company publications like the *A&P Tattle Tale* magazine. (Courtesy the Hartford Family Foundation.)

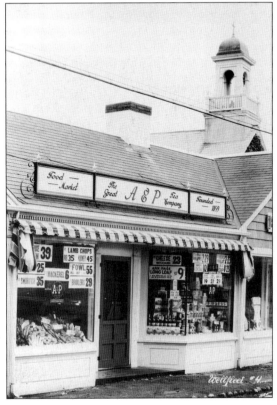

Most A&P stores during the Great Depression were leased by the company to avoid long-term investments, so many different building styles were used. This store in Wellfleet, Massachusetts, had a very New England feel. It was George L. Hartford's practice to lease new stores instead of buying them. Generally, they were one-year leases, with nine yearly options for renewal. This strategy helped A&P ride through the Great Depression with little to no losses. (Courtesy the Hartford Family Foundation.)

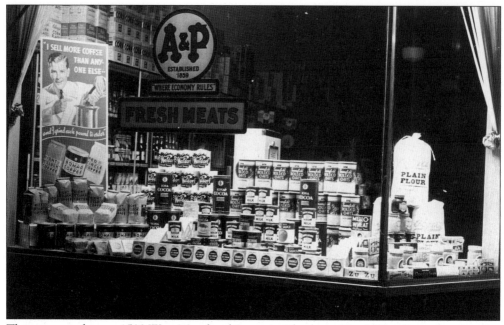

This store window, at 1500 West Morehead Street in Charlotte, North Carolina, advertises the diverse product line of a 1936 A&P. (Courtesy the A&P Historical Society.)

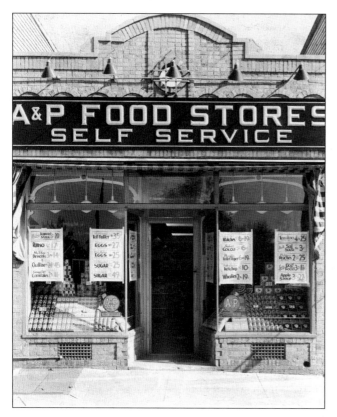

The A&P self-service store was the precursor to the supermarket. The self-service movement increased company profits in two important ways. It cut labor costs by eliminating the need for many clerks and increased sales volume, as customers serving themselves purchased more than they would have otherwise. The location of the store in this photograph is not identified. (Courtesy the A&P Historical Society.)

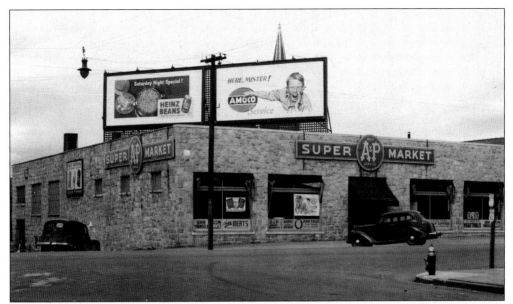

When other chains began opening supermarkets in the early 1930s, the Hartfords did not immediately jump on the bandwagon. Soon, however, the new self-service stores were stealing customers from A&P's combination stores. The company moved fast to catch up, closing six old-type stores for each new supermarket it opened. The number of stores dwindled from the 1930s peak of 15,737 to 4,682 by 1950. This unidentified early supermarket from the late 1930s had a prime corner location. (Courtesy the A&P Historical Society.)

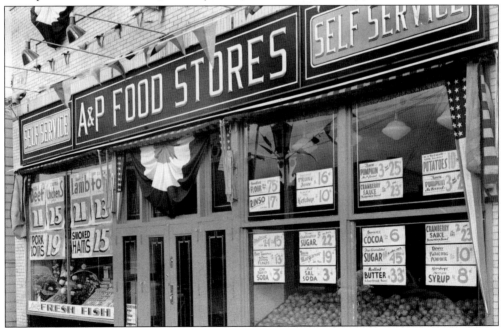

One of the first A&P supermarkets to open in the New York metropolitan area was this store in Hempstead, Long Island, in 1936. By the end of 1939, A&P supermarkets numbered over 1,100, while 2,000 smaller A&P grocery stores had been closed. (Photograph by Davis Studios; courtesy the Hartford Family Foundation.)

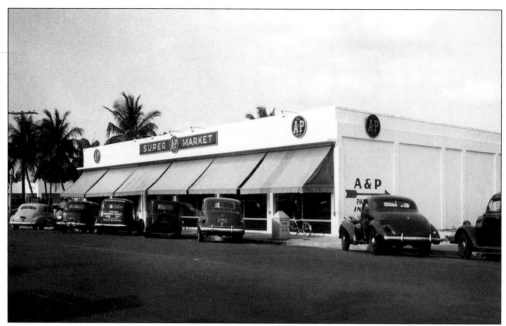

This photograph was taken in 1940 of the first A&P supermarket in West Palm Beach, Florida. The exact location is unidentified. (Courtesy the Hartford Family Foundation.)

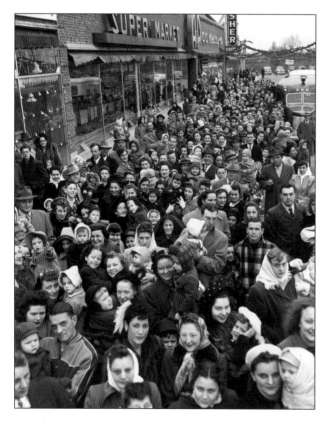

A Christmas celebration took place in 1947 at an A&P supermarket in Cleveland, Ohio, with a visit from Santa Claus that obviously attracted a large crowd. The store was located on the corner of Brook Park and Pearl Road and was the largest supermarket in Cleveland, with over 11,000 square feet. The store manager at that time was John Hoag. (Courtesy the Hartford Family Foundation.)

Two

A&P in American Advertising

GOOD NEWS TO LADIES.

ENTIRE NEW DEPARTURE. HAND-
SOME PRESENT to Every Customer.
Greatest offer. Now's your time to get orders
for our celebrated TEAS, COFFEES, and
BAKING POWDER, and secure a beautiful
Gold Band or Moss Rose China Tea Set, Din-
ner Set, Gold Band Moss Rose Toilet Set,
Watch, Brass Lamp, Caster, or Webster's
Dictionary. 3½ lbs. Fine Tea by Mail on
receipt of $2.00 and this "ad."

THE GREAT AMERICAN TEA CO.,

P. O. Box 289. 31 and 33 Vesey St., New York.

Beginning in the early 1860s and lasting nearly a decade, the Great American Tea Company was one of the country's leading advertisers. At that time, religious weeklies were the leading advertising mediums, and their readers were more likely to be teetotalers. Since tea was the Great American's premier product, the company began advertising in the *Methodist*, the *Christian Advocate*, the *Evangelist*, the *Christian Intelligencer*, and the *Christian Union*. In addition, it advertised in *Harper's Weekly*, the *American Agriculturist*, the *New York Independent*, *Moore's Rural New Yorker*, and the *New York Tribune*. The advertisements told a story with a clear message: Great American could sell better tea to more people at cheaper prices. This advertisement appeared in *Frank Leslie's Popular Monthly* in 1883. (Courtesy the Hartford Family Foundation.)

Reading material was not readily available in the mid-19th century, so circulars were written and distributed. They were designed to be interesting as well as informative, describing new tea deliveries, prices, and shipping policies. As early as the 1870s, advertisements promised premium gifts with bulk orders. This custom, die-cut trade card was designed in the shape of a bicycle, with the A&P store addresses as the wheel spokes. One of the most famous circulars, supplied to store customers as well as club members, featured the classic poem "A Visit from St. Nicholas," by Clement Clark Moore. (Courtesy the Hartford Family Foundation.)

Early advertising proved most effective through a medium that gave the customers free premiums. The most popular premiums given out by A&P and Great American during the 1880s were color lithographic trade cards of various sizes. With new printing processes developed at the time, these lithographs were economical to produce; many still exist today in antique stores and flea markets. The cards came in various sizes from large posters to small playing cards. The Hartford Family Foundation and A&P have both used these classic images in reproduction Christmas cards in recent years. (Courtesy the Hartford Family Foundation.)

Many trade cards of the 1880s were issued in numbered series and often had a moral message, such as "beware of the evils of drinking." There was also a series representing the four seasons and a series featuring portraits of American presidents. Die-cut cards in the shapes of fans, flower baskets, and artists' palettes were, and continue to be, the most collectible. (Courtesy the Hartford Family Foundation.)

A GIN COCKTAIL.
THE RESULT OF NOT USING
The Great Atlantic & Pacific Tea Cos
CELEBRATED TEAS & COFFEES

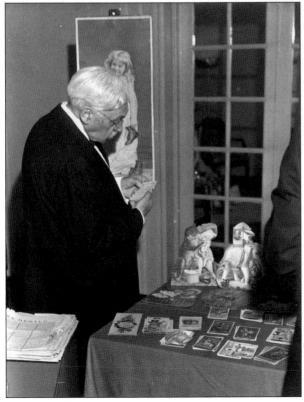

George Ludlum Hartford had the responsibility of choosing and purchasing the A&P trade cards in his early days with the company. His fondness for the sentimental images continued throughout his life. In his 80s, he still enjoyed looking through collections of early cards. He is shown here at a testimonial dinner given in 1947 for him and his brother John for their combined 130 years of service to A&P. (Courtesy the Hartford Family Foundation.)

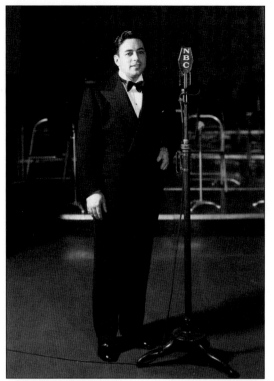

A&P took to the airways in 1924, when radio was still young. The A&P Radio Hour, featuring the music of Harry Horlick and the A&P Gypsies, was one of the first national radio programs. A small band of five players when they started, the orchestra grew under Horlick's leadership to one of the largest and most famous on the radio by 1940. The show, broadcast weekly throughout the country, was always opened by an announcer saying, "These are the A&P Gypsies, who come to you through the courtesy of the Great Atlantic & Pacific Tea Company." Horlick is pictured to the left at the microphone and below with the full orchestra in the NBC studios, where the radio program was broadcast. (Courtesy the Hartford Family Foundation.)

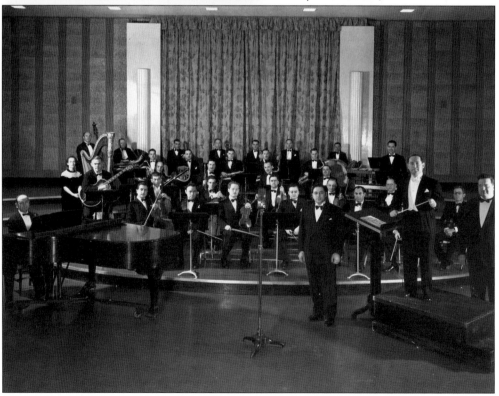

A&P undertook extensive magazine advertising campaigns from the 1920s through the 1940s with monthly full-page, color advertisements in popular magazines. A&P's advertisements were designed for the women of America's households and were considered ahead of their time. Note, however, how the roles of these women changed from the bride in the June 1928 *Ladies Home Journal* to the wartime factory worker in the August 1943 *Saturday Evening Post*. (Photographs by Jeff Martin; courtesy the Hartford Family Foundation.)

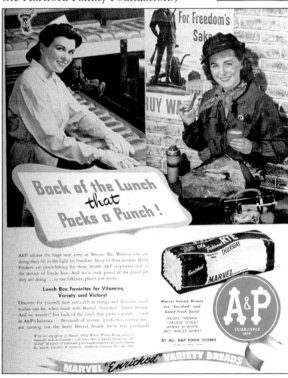

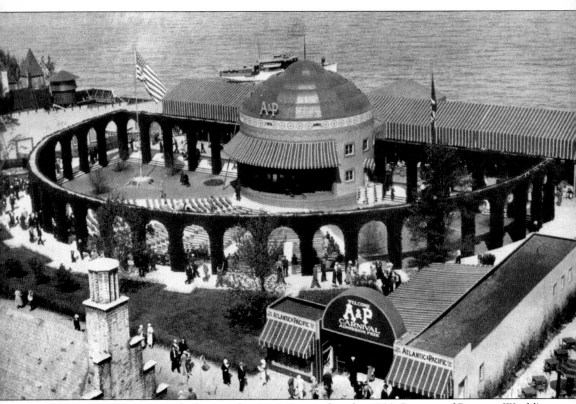

Held in a 2,000-seat amphitheater, the A&P Carnival at the 1933 Century of Progress World's Fair in Chicago drew thousands of visitors. People were entertained daily by the A&P Marionette Revue, a life-sized marionette show presented by Rufus Rose. They also enjoyed the music of Harry Horlick and the A&P Gypsies, featuring bandleader Harry Horlick and tenor Frank Parker. Other A&P Carnival attractions included a Quaker Maid exhibit with a 200-square-foot mural painted by artist Tony Sarg, a canopied boardwalk where tea dances were held, and American Coffee Corporation exhibits that gave out free samples of tea and coffee. (Courtesy the Hartford Family Foundation.)

Woman's Day magazine was started in 1937 by A&P through a wholly owned subsidiary, the Stores Publishing Company. It featured articles on food preparation, furniture and decorating, needlework instructions, and child care. Of course, it was filled with A&P product advertisements. By 1944, it had a monthly circulation of three million copies. This down-to-earth homemaker's guide sold for 2¢ at its start and increased to 5¢ by 1950. (Photograph by Jeff Martin; courtesy the Hartford Family Foundation.)

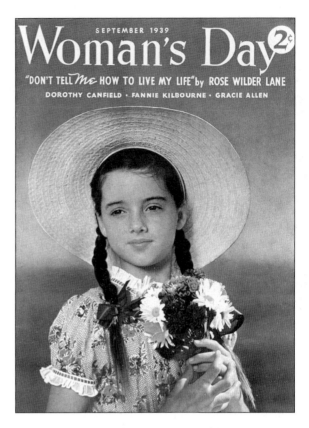

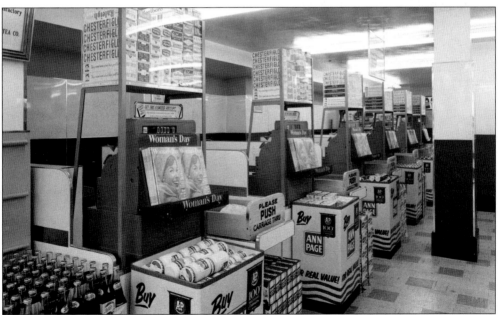

Woman's Day is prominently displayed at every checkout counter in this 1950s A&P store in Manhattan. The magazine was not sold by subscription. Four million copies of *Woman's Day* were sold in 1950 through A&P stores exclusively. (Courtesy the A&P Historical Society.)

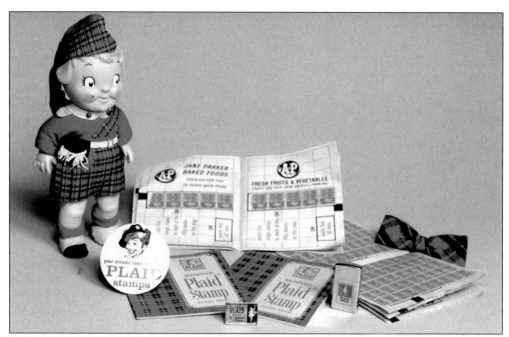

In 1963, A&P revitalized the premium concept with Plaid Stamps. Many people still remember helping their parents paste the little red, yellow, and blue stamps in a book and then, after the required number of books had been filled, trading them in for card tables, transistor radios, and TV snack trays. A store poster announcing the new program stated, "Plaid brings excitement to stamp saving. Plaid offers new services, new gifts, new stamp saving fun. Plaid Stamps are different and that's why Plaid is The Stamp you should save." (Photograph by Jeff Martin; courtesy the Hartford Family Foundation.)

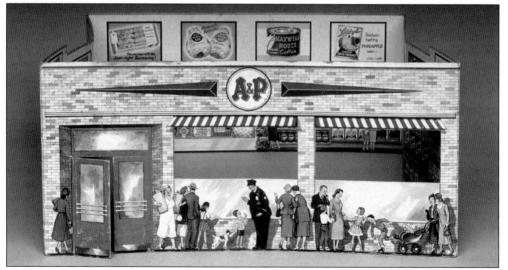

Although this toy A&P store from the 1960s featured other products than A&P's own brands, it taught little shoppers early loyalty to their favorite grocery store. Child shoppers were always welcome in the early A&P stores. Managers' manuals urged employees to treat young shoppers with respect. Their mothers would, in turn, remain loyal customers. (Photograph by Jeff Martin; courtesy the Hartford Family Foundation.)

Three

THE COMPANY EMPLOYEES

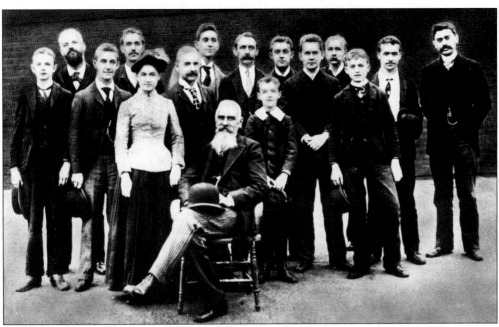

This 1890 photograph of A&P office workers at Vesey Street includes, from left to right, Edward Welsh, Thomas B. Smith, Frederick C. Doherty, E.W. Haskins, E. Bishop, A.C. Corwin, John A. Hartford, George Huntington Hartford (seated), William Corkill, Philip Welsh, William Sidney Hillyer, Hamilton Platt, Andrew Beagen, William Hickey, David T. Force, and George Ludlum Hartford. George L. Hartford is 25 years old and John Hartford only 18. George Huntington Hartford died while vacationing in Spring Lake, New Jersey, on August 24, 1917. He was 84 years old and had suffered from a brief illness. Upon his death, A&P's founder carefully left a will that passed ownership of the company to the heirs of his five children, with the provision that John and George Hartford were to have administrative control until their deaths. "Mr. John" became president of the company, and "Mr. George" chairman of the board. For one more generation, A&P continued as business owned and operated by the Hartford family. (Courtesy the Hartford Family Foundation.)

George Ludlum Hartford (right) began his career with A&P at age 15 as the chief cashier of the New York store. For many years, he had the time-consuming task of counting the company's daily income, bill by bill. In the 1880s, he asked a chemist friend for the ingredients used in making baking powder. He thought they must be extremely rare, since its price was so high. The friend explained that baking powder was simply a combination of alum and bicarbonate of soda. Soon, the back section of the company's Vesey Street store was curtained off, and a chemist was hired to make baking powder, which A&P sold under its own name at a fraction of the going price. This was A&P's first in-house consumer product, and it marked the beginning of the company's manufacturing operations.

John Augustine Hartford (left), seven years younger than his brother George, began working in the New York store as a $5-a-week clerk in 1888. He filled ink wells and helped his older brother choose the full-color lithographs that the company gave away as premiums. He also spent a few years in apprenticeship, learning all aspects of the business. Unlike his brother, who was primarily interested in finances, John's talents were in merchandising and business operations. He carefully developed new promotions and decided what items should be purchased as premiums. Unlike his quiet, unassuming brother, John was a "people person" and, in the prime of his career, visited thousands of A&P stores in a single year. (Courtesy the Hartford Family Foundation.)

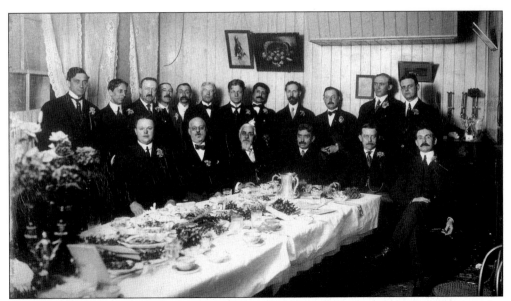

The attitudes and morale of the employees have always been very important to A&P. Men who began careers with A&P as stock or delivery boys were encouraged to work their way up through the ranks as far as their abilities would take them. This dinner meeting of upper management personnel took place on April 11, 1908. The men at this table were A&P career men. They are, from left to right, as follows: (front row) Oliver C. Adams, T.B. Smith, George Huntington Hartford, George Ludlum Hartford, C.P. Jacobson, and A. B. McCormick; (back row) John A. Hartford, C.J. Haskins, C.S. Rhinehardt, C.A. Reilly, William Corill, Charles A. Brooks, Arthur G. Hoffman, A. Hirscler, Edward W. Haskins, William S. Hillyer, C.P. Wilson, and Robert B. Smith. (Courtesy the Hartford Family Foundation.)

In order to help their managers develop professional management skills and also to foster good fellowship among employees, A&P established the Manager's Benefit Association in 1916. It was organized by William Sidney Hillyer, a lifelong employee who was also an accomplished writer with two books of poetry to his credit. Hillyer began work at A&P in 1886, two years prior to John Hartford. He is present at the meeting shown in the previous image—already a part of upper management in 1908. He is seen here with John and George Hartford in 1936, celebrating his 50th anniversary with the company. (Courtesy the Hartford Family Foundation.)

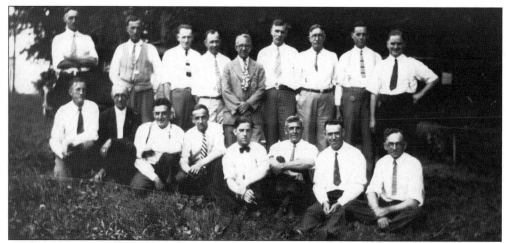

The Managers Benevolent Association (MBA) organized regular monthly meetings during which employees could learn about methods of advancement, merchandising, sales drives, and contests. It also sponsored social outings, dinners, and excursions for members and their families. Pictured are MBA members enjoying the annual picnic in Wheeling, West Virginia. It was held on Saturday, July 16, 1927, at Milner's Grove. (Courtesy the Hartford Family Foundation.)

With 53 associations already established by the early 1920s, the MBA had begun publishing a magazine to report on its events. It was printed by A&P in one of the largest private printing plants in the country. It was here that giant two-color presses printed product labels, order forms, checks, letterhead, envelopes, circulars, and the monthly issues of the *A&P Tattle Tale*. A sophisticated publication for the times, the February 1923 issue was 40 pages long and featured product news, meeting notes from around the country, news tidbits about employees, and employee-created poems, short stories, and drawings. (Photographs by Jeff Martin; courtesy the Hartford Family Foundation.)

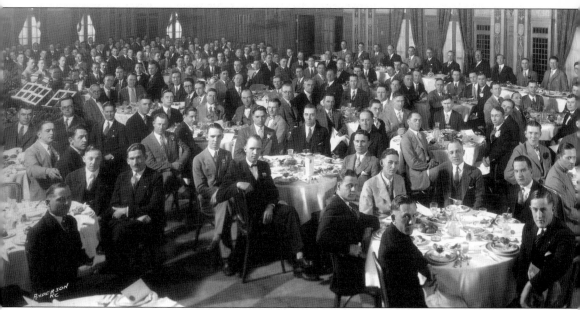

The MBA idea caught on so well that by 1925 there were 72 associations around the country. By 1930, 15,000 A&P managers were members of MBA in 134 branches among the company's five divisions. Each division had a representative who visited the individual associations and assisted with business and financial difficulties. This photograph was taken on May 8, 1927, at the first annual MBA banquet of the Kansas City branch. (Courtesy the Hartford Family Foundation.)

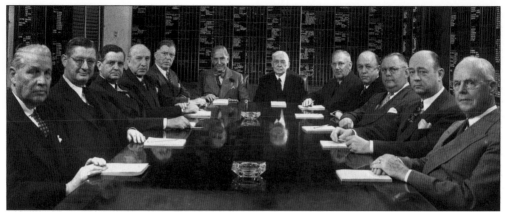

In 1925, A&P decentralized and split the growing company into seven regional divisions. All individual division presidents were lifelong career men still on the job when this photograph was taken in 1950. This A&P directors' meeting took place at headquarters in New York City. Seated, from left to right, are president Ralph W. Burger, comptroller John D. Ehrgott, New England division president Lawrence M. Cazayoux, central western division president John M. Toolin, eastern division chairman William M. Byrnes, board chairman John A. Hartford, treasurer George L. Hartford, southern division president Robert M. Smith, central division president Robbins L. Pierce, Atlantic division president William F. Leach, Midwest division president Dwight B. Austin, and Atlantic and southern division chairman Oliver C. Adams. (Photograph by Herbert Gehr, *Life* magazine; courtesy the A&P Historical Society.)

Ralph W. Burger began his employment at A&P as a clerk in 1910 in a small store in Glen Falls, New York. He worked his way up through the ranks and eventually became the personal assistant of John and George Hartford. He gained the two men's confidence in his leadership abilities and, in 1950, was named president. In the fall of 1958, Burger was named chairman of the board as well as president. (Courtesy the Hartford Family Foundation.)

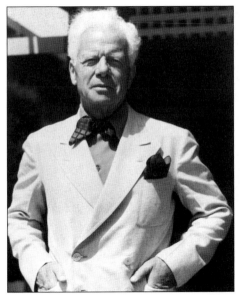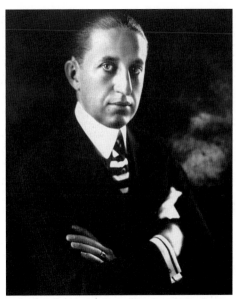

Although the daughters of George Huntington Hartford did not work in the family business, the men in their lives did. Arthur Gilman Hoffman (left) was married to John and George Hartford's younger sister, Marie Louise. Hoffman worked for A&P when he met Marie and was later promoted to the position of vice president in charge of A&P's sugar procurement. William G. Wrightson (right) was the son-in-law of John and George's older sister, Minnie. Wrightson was a Princeton graduate who took the job of vice president in charge of advertising, managing annual $6 million advertising budgets and national magazine campaigns during his career with the company. (Courtesy the Hartford Family Foundation.)

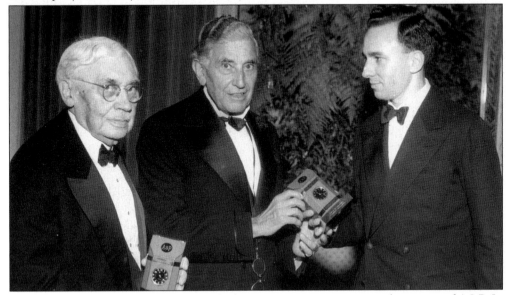

The longevity of John and George Hartford's careers was a testimony to the success of A&P. In 1947, they were honored with a dinner at the Waldorf-Astoria Hotel in New York City and were presented with commemorative Cartier clocks for their combined 130 years of service to A&P. In this photograph, they receive their clocks from their nephew Huntington Hartford. (Courtesy the Hartford Family Foundation.)

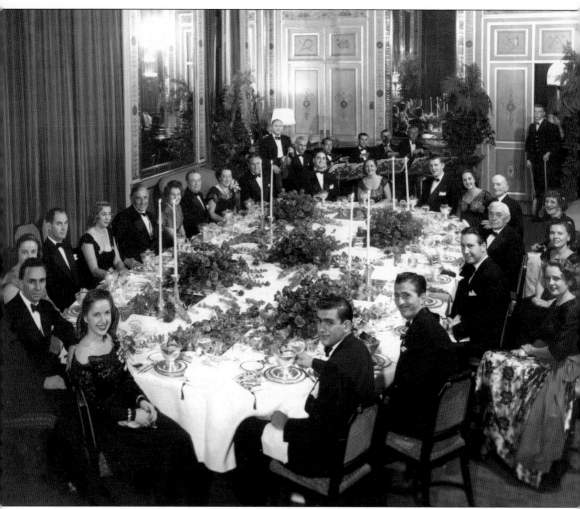

The descendants of George Huntington Hartford gave a dinner for John A. and George L. Hartford in 1947 in the Waldorf-Astoria. The party featured music by the A&P orchestra, Harry Horlick and the A&P Gypsies (seen in the background). The guests included Minnie Wrightson Besch, Huntington Hartford, Cynthia Wrightson Kluxen, Barclay Douglas, Josephine Hartford Douglas, John A. Hartford, Dolly Clews, Sheldon Stuart, Alice Reilly, Paul Switz, William G. Wrightson, Olivia Wrightson Switz, Robert W. Besch, Martha Wrightson Ramsing, William B. Reilly, Pauline Hartford, George Ludlum Hartford, Josephine Hoffman McIntosh, Thor Ramsing, Rachel Carpenter, and Alan McIntosh. (Courtesy the Hartford Family Foundation.)

Four
THE HARTFORD ERA

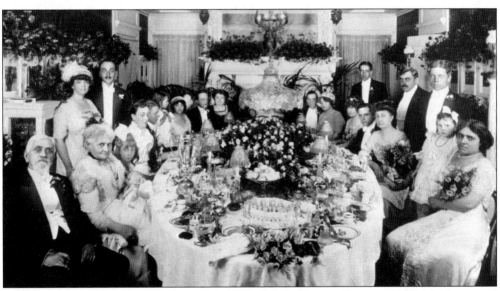

A&P cofounder George Gilman retired in 1878, making George Huntington Hartford an equal partner with exclusive responsibility for the management and control of their business. Thus began the Hartford era, in which the company was kept under the exclusive control of George and his two sons, George and John, from 1878 until 1957. In 1911, the entire Hartford family came together to celebrate the 50th wedding anniversary of Josephine and George Huntington Hartford. The party took place at the Deal, New Jersey home of their son Edward on July 24. Shown from left to right are the following: (front row, sitting) George H. Hartford, founder; Josephine L. Hartford, holding Huntington Hartford; Marie Josephine Hartford; Mabel Stewart; Sheldon Stewart; Olivia Wrightson; Josephine Clews Wrightson; William B. Reilly; Minnie Hartford Reilly; John A. Hartford, president; Pauline C. Hartford; Dolly Clews; George D. Clews, treasurer; Josephine B. Hartford; Josephine Hoffman; and Marie Louise Hartford Hoffman; (back row, standing) Henrietta Hartford; Edward V. Hartford; William G. Wrightson, vice president; George L. Hartford, chairman; and Arthur G. Hoffman, vice president. (Courtesy the Hartford Family Foundation.)

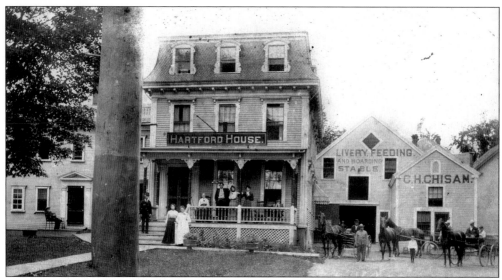

George Huntington Hartford's American ancestry dates back to the late 1600s, when Nicholas Hartford (Harford) is believed to have arrived in Dover, New Hampshire, from his homeland in Herfordshire, England. Nicholas was George H. Hartford's great-great-great-grandfather. George's grandfather Daniel Hartford married Mary Livermore in 1796 and moved to Augusta, Maine. George's father, Joshua B. Hartford, was raised there. In 1832, he married Martha Marie Soren. They had two sons—George Huntington, born in 1833, and John Soren Hartford, born in 1836. Joshua and Martha ran a boardinghouse and livery stable in the center of Augusta. Josephine and George Huntington Hartford took this photograph while visiting the Hartford family homestead c. 1910. (Courtesy the Hartford Family Foundation.)

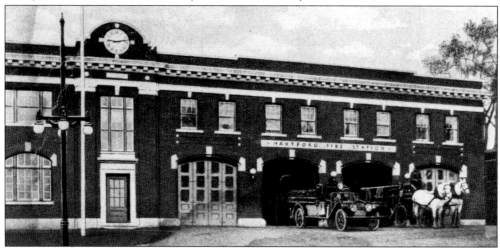

In their later years, George Huntington Hartford brought his father and mother to Orange, New Jersey, where they died in 1877 and 1878, respectively. George Huntington's eldest son, George Ludlum Hartford, inherited the Augusta property. In 1918, he sold the property to the city of Augusta for $1 so that the centrally located land could be used for a fire station. George Ludlum Hartford stipulated in the agreement that the land must be used for a firehouse and that the building must support a large clock, always set at the correct time. This early photograph shows the Augusta Firehouse sporting its famous clock. A modern fire station has been built on that site today. (Courtesy the Hartford Family Foundation.)

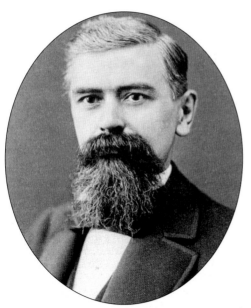 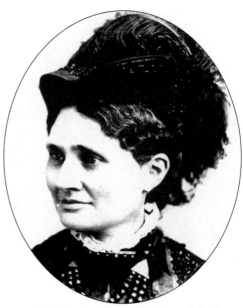

On July 24, 1861, George Huntington Hartford married Marie Josephine Ludlum of Goshen, New York, and moved into a small house in Brooklyn. Josephine and George's first two children were born in Brooklyn (Marie Josephine in 1862 and George Ludlum in 1865). The couple moved to Orange, New Jersey, in 1866, the same year that George was made a partner in the Great American Tea Company. These photographs are the earliest known of the Hartfords and were perhaps taken in mid-1870s. (Courtesy the Hartford Family Foundation.)

Josephine and George Huntington Hartford were affectionately known by their family members as "Mata" and "Pata." These oil portraits of them were rendered about the time of their 50th wedding anniversary in 1911. The couple was to have six more years together before George's death in 1917. Josephine lived for eight more years, dying in 1925 at the age of 88. (Photographs by Jeff Martin; courtesy the Hartford Family Foundation.)

The Hartford family home on Ridge Street in Orange was purchased in 1870 and remained in the family long after Josephine Hartford's death in 1925. The Hartfords' youngest daughter, Marie Louise, married Arthur Hoffman, and the Hoffman family made their home with the elder Hartfords. When Marie died in 1927, just two years after her mother, her husband and two teenage daughters continued to live in the Ridge Street home. (Courtesy the Hartford Family Foundation.)

The Hartford Family Tree

George Huntington Hartford
b. 9-5-1833 d. 8-29-17
Marie Josephine Ludlum
b. 2-2-1837 d. 12-10-25

George Ludlum Hartford	**John Augustine Hartford**
b. 11-5-1865 d. 9-24-57	b. 2-10-1872 d. 9-20-51
Josephine Burnet Logan	Pauline Augusta Corwin
b. 6-6-1861 d. 5-9-44	b. 7-18-1872 d. 9-5-48

Maria Josephine Hartford	**Edward Vassallo Hartford**	**Marie Louise Hartford**
b. 8-15-1862 d. 10-29-41	b. 5-28-1870 d. 6-30-22	b. 9-18-1875 d. 5-15-27
John Edward Clews	Henrietta Guerard Pollitzer	Arthur Gilman Hoffman
b. 1857 d. 1901	b. 1-4-1881 d. 6-3-48	b. 4-30-1872 d. 2-16-47

Josephine Estelle Clews	**Marie Josephine Hartford**	**Josephine Hoffman**
b. 2-12-1883 d. 3-2-39	b. 8-20-02 d. 6-8-92	b. 1-17-08 d. 2-6-71
John Hartford Clews	**George Huntington Hartford II**	**Marie Hartford Hoffman**
b. 2-20-1885 d. 9-3-06	b. 4-18-11	b. 6-10-12 d. 4-19-72
George Douglas Clews		
b. 12-29-1886 d. 12-5-40		
Louis Raymond Clews		
b. 8-8-1888 d. 11-5-08		

This Hartford family tree shows A&P founder George Huntington Hartford's five children and eight grandchildren. In his will, it was stipulated that the preferred stock of A&P be divided equally among his five children. (Courtesy the Hartford Family Foundation.)

With a growing prosperous business under his management, George Huntington Hartford rapidly became one of the wealthiest men in Orange. In 1877, the Democratic Party came seeking his nomination for the city's upcoming mayoral race. In 1878, Hartford was elected mayor of Orange, an unpaid and time-consuming post in which he served 12 one-year terms. Many improvements were instituted in Orange during Hartford's tenure as mayor. In 1888, Orange became the first New Jersey city to install streetlights. (Courtesy the Hartford Family Foundation.)

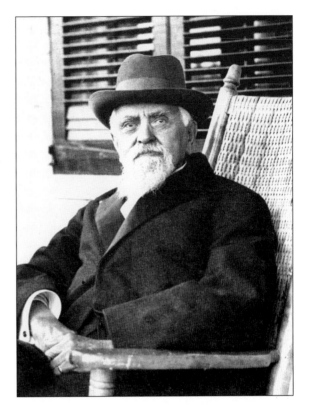

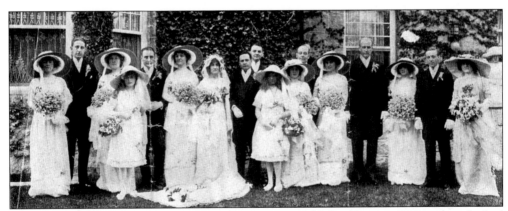

The Hartfords' eldest daughter, known as Minnie, married John Clews in 1881, a man she had met while vacationing in Lakewood, New Jersey. Almost 30 years later, a Lakewood, New Jersey resort was the site of her son George's wedding in 1910. The wedding party includes, from left to right, Marguerite Broughton, William G. Wrightson, Marjorie Winants, Maud Bush, James Hine, Mrs. Arthur Foster, Dolly Lynch Clews (bride), George Douglas Clews (groom), S.V.B. Brewster, Peggy Lynch, Adele Grenet, W.E. Swindell, Louise Freeman, John Breckenridge, Josephine Clews Wrightson, Walton Graft, and Louise Lynch. (Courtesy the Hartford Family Foundation.)

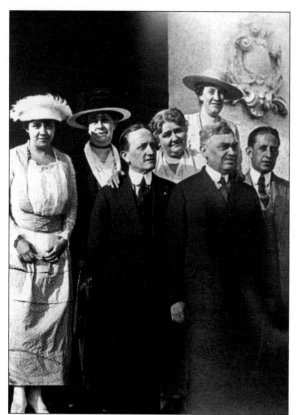

Maria Josephine Hartford (known as Minnie), the Hartford's eldest daughter, purchased a home adjacent to her parents in Orange. Minnie outlived all four of her children, and her home became a haven for her many grandchildren—a place where they could come and escape the watchful eyes of their parents. Family members say that in the years they were neighbors, Minnie visited her mother every day. Her summer home in Allenhurst, New Jersey, brought many members of the Hartford clan to the Jersey Shore for summer vacations. Pictured here on Minnie Reilly's Allenhurst porch during the mid-1930s are, from left to right, Josephine Clews Wrightson, Josephine Burnet (Mrs. George L.) Hartford, William B. Reilly, Minnie Hartford Reilly, Mabel Stuart, George Ludlum Hartford, and William G. Wrightson. (Courtesy the Hartford Family Foundation.)

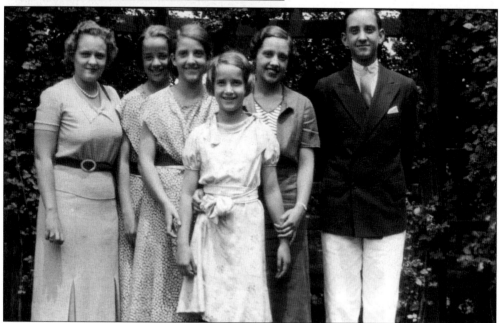

Minnie Hartford Reilly's grandchildren pose outside her Orange, New Jersey home c. 1935. They are, from left to right, Rachel Clews, Cynthia Wrightson, Martha Wrightson, Minnie Wrightson, Olivia Wrightson, and Bill Wrightson. (Courtesy the Hartford Family Foundation.)

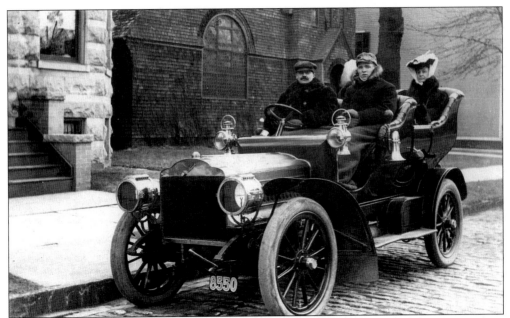

Josephine and George Huntington Hartford's eldest son, George Ludlum Hartford, was an avid automobile enthusiast. In his later years, he took motors apart and put them back together just to see how they operated. He is seen in his hometown of Montclair with his wife, Josephine, and son-in-law Sheldon Stuart. From the style of this open touring car, the date is c. 1915. (Courtesy the Hartford Family Foundation.)

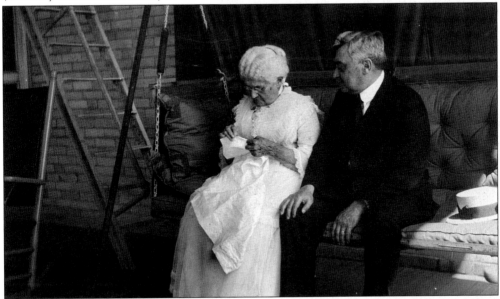

George Ludlum Hartford sits with his mother, Josephine Ludlum Hartford, while she sews on the porch of the New Monmouth Hotel in Spring Lake, New Jersey. It was the summer of 1919, and Mata was 82 years old. Upon her death six years later, William S. Hillyer of A&P wrote a tribute to her in the January 1926 *A&P Tattle Tale*, which read in part, "Her counsel and foresight reached far down through the varied years and affected men even beyond the confines of relationships. She was an inspiration." (Courtesy the Hartford Family Foundation.)

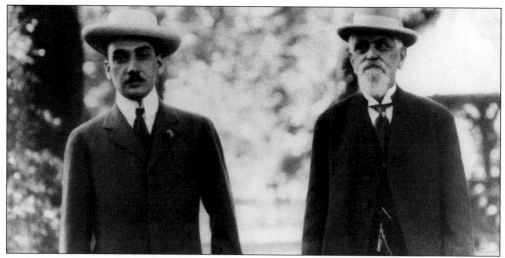

The Hartfords' middle child, Edward Vassallo Hartford, was born in 1870. He attended the Stevens Institute of Technology and then spent a few years traveling in France and India. Although Edward Hartford held the position of secretary of A&P at one time, he was never involved in the day-to-day business of running the company. Edward was an inventor and made a fortune in his own right by manufacturing the Hartford shock absorber and many other automobile accessories. He is pictured with his father, George Huntington Hartford, in Orange, New Jersey, c. 1900. (Courtesy the Hartford Family Foundation.)

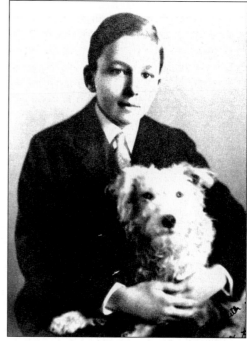

Edward Hartford married Henrietta Pollitzer in 1901 and had two children—Marie Josephine, born in 1902, and George Huntington Hartford II, born in 1911. Henrietta is shown to the left c. 1900. George Huntington Hartford II and his dog are to the right in 1920. Later known as Huntington Hartford, he became widely known as an art patron and philanthropist. (Courtesy the Hartford Family Foundation.)

Josephine Hartford O'Donnell, daughter of Edward and Henrietta Hartford, is shown with her uncle John A. Hartford at her daughter Nuala's wedding to Claiborne Pell in New York City on December 16, 1944. (Courtesy the Hartford Family Foundation.)

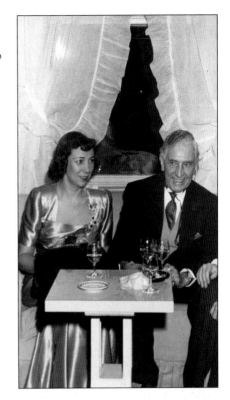

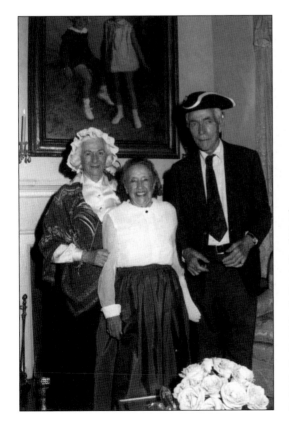

Nuala and Claiborne Pell are shown at their home in the Georgetown section of Washington, D.C., with their cousin Olivia Wrightson Switz (center) in May 1994. The Pells were hosts to the extended Hartford family for their annual reunion. The guests participated in a dinner-mystery entertainment, the *Hartfords of Colonial America*, which explains their attire. Claiborne Pell served as a U.S. senator from 1960 to 1996, representing his constituents in Rhode Island. (Photograph by Greg Brower; courtesy the Hartford Family Foundation.)

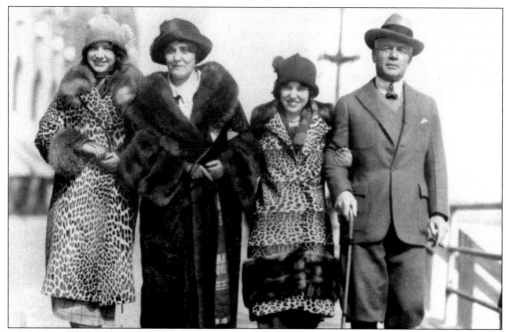

Marie Louise Hartford, the youngest child of Josephine and George Huntington Hartford, married Arthur Gilman Hoffman in 1907. The couple had two daughters—Josephine, born in 1908, and Marie, born in 1912. Pictured walking the boardwalk in Atlantic City *c.* 1925 are, from left to right, Marie Hoffman, Marie Louise Hartford Hoffman, Josephine Hoffman, and Arthur Gilman Hoffman. (Courtesy the Hartford Family Foundation.)

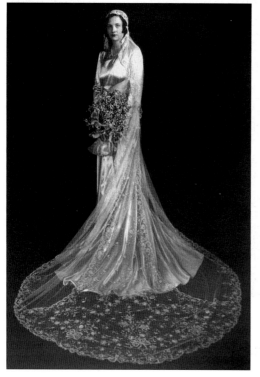

Pictured is Marie Hartford Hoffman on her wedding day in 1931 in Orange, New Jersey. The wedding took place at the former home of her late grandparents, Josephine and George Huntington Hartford, where she had grown up. (Courtesy the Hartford Family Foundation.)

Josephine Hoffman, the eldest daughter of Marie and Arthur Hoffman, married Alan McIntosh in 1928. The couple is pictured at a testimonial dinner for her uncles, John and George Hartford, held in 1947. (Courtesy the Hartford Family Foundation.)

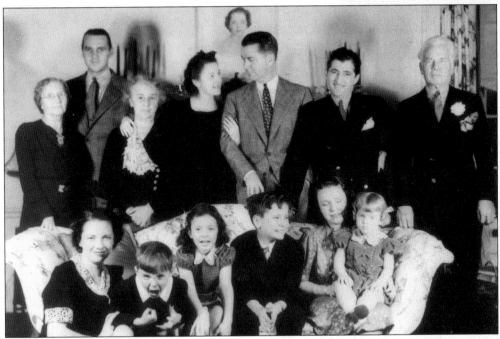

The Hoffman sisters are shown at a family gathering with their own families in 1940. Pictured from left to right are the following: (front row) Marie Hoffman Robertson, Michael McIntosh, Mimi Robertson, Peter McIntosh, Josephine Hoffman McIntosh, and Joy McIntosh; (back row) unidentified, Charles Robertson, Anna G. Robertson, Marjorie Rose, Donald Rose, Alan McIntosh, and Arthur Hoffman. (Courtesy the Hartford Family Foundation.)

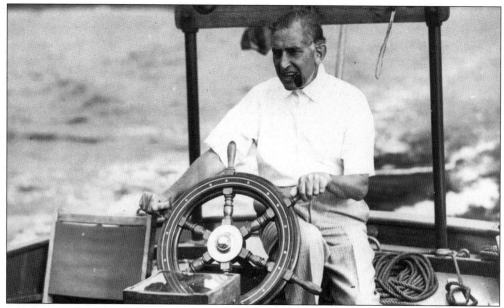

Josephine and George Huntington Hartford's youngest son, John Augustine, was a handsome, hardworking, impeccably dressed, and quick-witted man. In his early career, his days were long, and he frequently traveled to stores and meetings around the country. In later years, he vacationed in Palm Beach, Florida, during the winter, staying at the Breakers Hotel. He is seen captaining a boat in Florida with the same intensity that he gave to sales analysis meetings at A&P headquarters. (Courtesy the Hartford Family Foundation.)

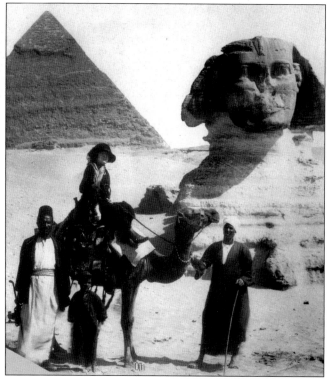

Pauline and John A. Hartford were married in 1893 when they were both 22 years old. The pressures of John's tremendous workload while building a successful business, along with the couple's increasing fortune, caused the couple to drift apart. John became infatuated with a young model named Frances Bolger, and the Hartfords separated in 1915. Pauline Hartford traveled to many foreign countries such as Egypt and Japan during her 10-year separation from husband John. She is shown riding a camel in front of the Great Pyramid in 1920. (Courtesy the Hartford Family Foundation.)

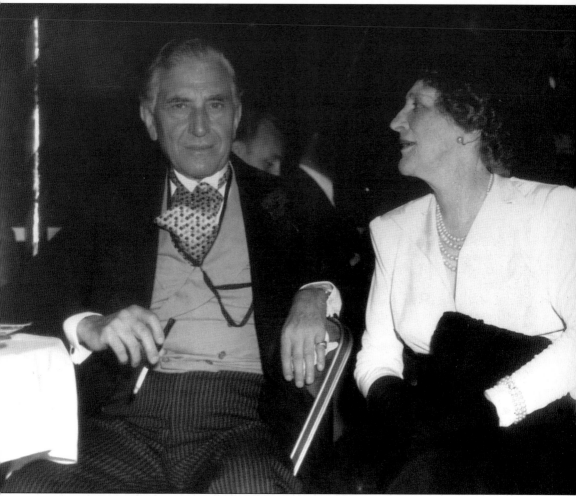

Pauline and John A. Hartford were remarried in 1925 in Paris after a 10-year separation. They are seen here in 1941, looking like they had never spent a moment of their lives apart. (Courtesy the Hartford Family Foundation.)

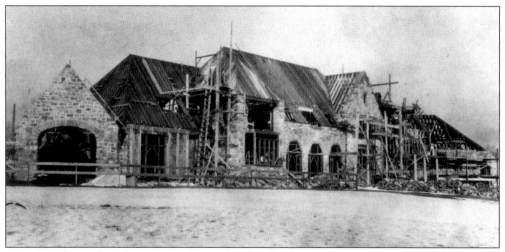

In 1928, John and Pauline Hartford completed construction of a Tudor manor house on their estate, Buena Vista Farm, in Valhalla, New York. The couple used this home as their weekend and summer retreat and spent the winter weeks in an elegant suite at the Plaza Hotel in Manhattan. Three greenhouses, a blacksmith shop, two additional houses, a nine-hole golf course, and an 80- by 200-foot indoor riding ring with a private tanning salon were some of the estate's additional features. It is shown here under construction in late 1927. It is shown below after completion in 1928. (Courtesy the Hartford Family Foundation.)

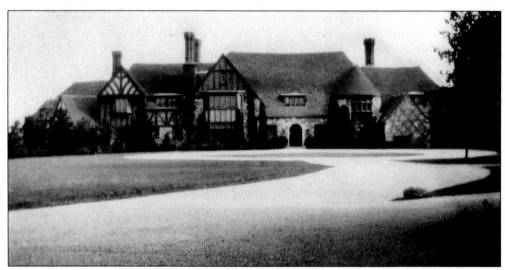

Many of the bedrooms in the 29-room Buena Vista mansion had built-in safes and secret panels that opened at the touch of a button. The bathrooms were fitted with gold fixtures, and each was tiled in a bold color such as yellow, turquoise, or lavender. Paneling of oak, walnut, and poplar was evident throughout the elegant home. Wallpaper murals depicting Greek castles and gothic towers lined the second-floor hallway. A large winding staircase with a custom-designed stained-glass window and a private movie screening room were among the more spectacular elements that made the home unique. (Courtesy the Hartford Family Foundation.)

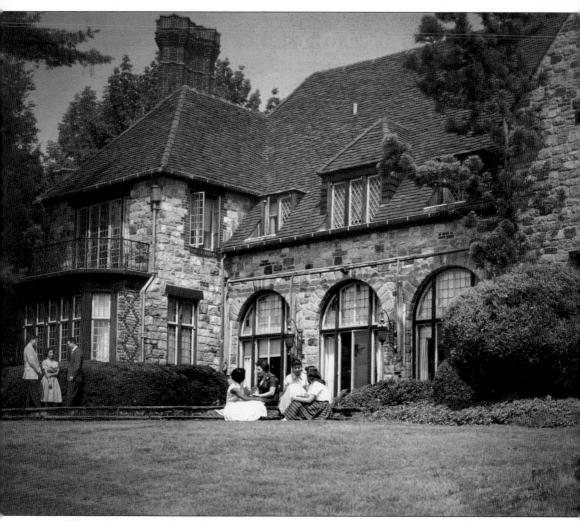

In 1953, Buena Vista Farm was transformed from a private residence to Westchester Community College, which now sprawls over the property's 300 acres. The Hartfords' former manor house now serves as an administration building and office of the college president. In 1979, the John A. Hartford House was declared a National Historic Landmark by the U.S. Department of the Interior. (Courtesy the Hartford Family Foundation.)

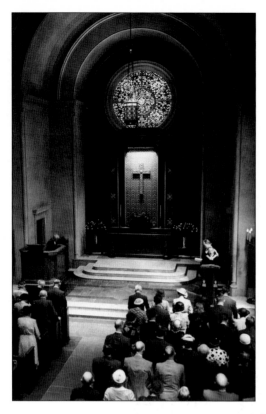

In 1929, John Hartford created the John A. Hartford Foundation. He and his brother George left the bulk of their estates to the foundation. Its 1958 annual report described the founder's philosophy on its charitable giving: "Neither John Hartford nor his brother George, in their bequests to the Foundation, expressed any wish as to how the funds they provided should be used. . . . Our benefactors' one common request was that the Foundation strive always to do the greatest good for the greatest number." Based on the pattern of John's previous giving, the foundation chose to support biomedical and clinical research. One of John's proudest bequests was the Pauline A. Hartford Memorial Chapel, which the foundation built at Columbia Presbyterian Hospital in memory of his wife. This is the chapel's dedication ceremony in 1952. Today, the John A. Hartford Foundation, based in New York City, has assets of over $500 million and focuses on research and medical programs that address the problems of our nation's elderly. (Courtesy the Hartford Family Foundation.)

Pictured is Nellie Manning in 1963 at her desk in the John A. Hartford Foundation headquarters. A lifelong A&P employee, Nellie began work as a secretary c. 1910, when the company was still based in Jersey City, New Jersey. She worked her way up to become the personal secretary to both John and George Hartford. No visitor got in to see either of the brothers without her approval. After the death of the Hartfords, Manning went daily to the John A. Hartford Foundation's offices in the Chrysler Building to make sure that the wishes of her former employers were being honored. She died in 1984 at the age of 94. (Courtesy the Hartford Family Foundation.)

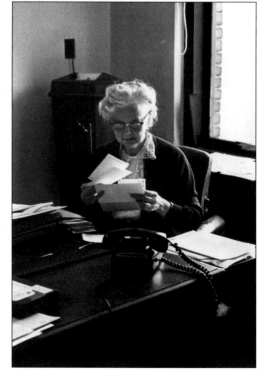

Five

THE LARGEST
COFFEE RETAILER

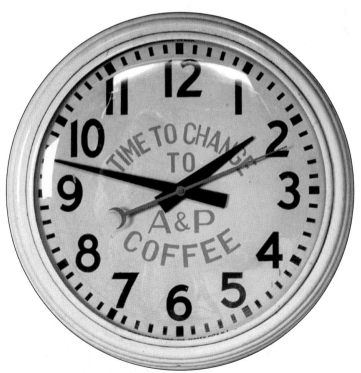

A&P was launched by drastically reducing the cost of tea, a popular but expensive commodity in the 1880s. Tea sales were so successful that the company soon added coffee as its popularity spread through advertising and circulars. Coffee was packaged in a red bag and named Eight O'Clock Breakfast Coffee by George Huntington Hartford. This clock was a fixture in every A&P coffee department for many years. (Photograph by Jeff Martin; courtesy the Hartford Family Foundation.)

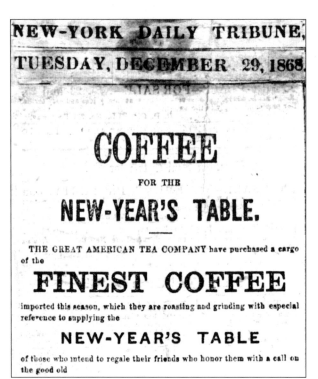

NEW-YORK DAILY TRIBUNE,
TUESDAY, DECEMBER 29, 1868.

COFFEE

FOR THE

NEW-YEAR'S TABLE.

THE GREAT AMERICAN TEA COMPANY have purchased a cargo of the

FINEST COFFEE

imported this season, which they are roasting and grinding with especial reference to supplying the

NEW-YEAR'S TABLE

of those who intend to regale their friends who honor them with a call on the good old

The Great American Tea Company added coffee to its inventory as early as 1868, as evidenced by this advertisement in the *New York Daily Tribune* of December 29. The early advertisements frequently included letters of endorsement from satisfied customers, such as this one in the November 1, 1866 *New York Independent*: "Gents—Please allow me to say to you that your Teas and Coffees sent me in orders No. 1 and 2 are recommended by all who use them, and are as good, if not better, than our $2 tea at this place. Every one praised them, and you will get another order from me soon. I remain yours, very truly, J.M. Hodges, Almond, NY." (Courtesy the Hartford Family Foundation.)

In 1907, A&P moved its corporate headquarters from lower Manhattan to Jersey City. Sales were up to $15 million a year from the company's 370 stores. This large complex served as corporate headquarters for 20 years. The first A&P coffee-roasting plant was established at the Jersey City site in 1908 as part of the huge corporate headquarters location. From there, roasting plants were opened around the country to expedite delivery of this perishable product to stores. By 1947, A&P regulated its deliveries to stores so that most of it was sold within 10 to 14 days of roasting. This rare Pacific-brand coffee can boasts a picture of the Jersey City headquarters. (Photograph by Jeff Martin; courtesy the Hartford Family Foundation.)

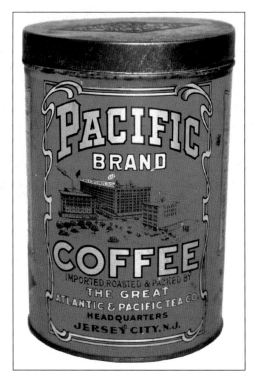

The American Coffee Corporation was incorporated in 1919 as a wholly owned subsidiary of A&P. George D. Clews, a grandson of George Huntington Hartford, served as its first president. In 1928, Berent Friele became president of American Coffee, and George Clews was named treasurer of A&P. (Courtesy the Hartford Family Foundation.)

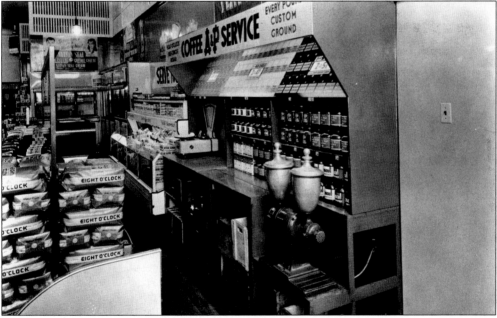

By 1929, A&P was the world's largest coffee retailer. From 1939 through 1941, the American Coffee Corporation achieved profits greater than all its retail stores combined. In the mid-1940s, A&P sold 111,000 tons of coffee with sales of close to $64 million. Even with competition from other national brands in A&P stores, 90 percent of the coffee sold was its own. This A&P coffee service department was located in an Ohio A&P in the mid-1940s. (Courtesy the Hartford Family Foundation.)

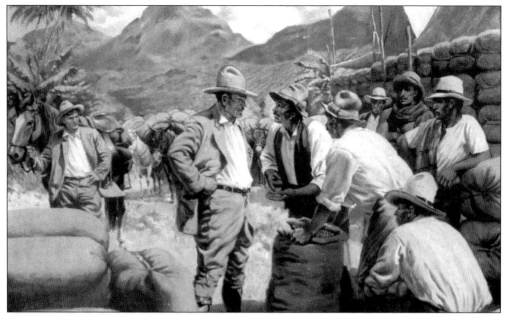

By the late 1940s, almost 90 percent of A&P coffee was bought in Brazil and Colombia by American Coffee Corporation buyers. American Coffee bought directly from growers in the interior regions of South America, from holders in Santos, Brazil, or through a network of coffee subagents. After the green coffee was blended into uniform lots, A&P took possession and shipped it to its nine blending and roasting plants around the country. This Anton Otto Fischer painting, part of the collection of the Great Atlantic & Pacific Tea Company, depicts the coffee-buying process in South America.

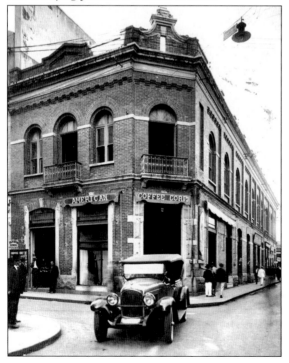

American Coffee's Brazilian headquarters in Santos occupied an entire building, housing offices, storage bins, and blending rooms. The warehouse employed experienced mixers, baggers, and loaders, constantly at work receiving coffees and preparing them for shipment to the United States. Coffee was transported by steamship, which made the trip from Brazil to the United States in about 22 days. (Photograph by C.W. Weise, May 1931; courtesy the Hartford Family Foundation.)

Cup tasting was one of the most widely advertised features of the A&P coffee industry and an important element of coffee's popularity. All coffee was subjected to the most rigid series of tests—first in the countries where it was grown, next upon its arrival in the United States, and again in the roasting plants. The coffee testers who performed these tests were carefully trained, and every batch passed exacting requirements before it reached A&P stores. The cups were placed before the testers on a revolving table together with samples of the roasted beans, as shown in this painting by Anton Otto Fischer. The painting is in the collection of the Hartford Family Foundation.

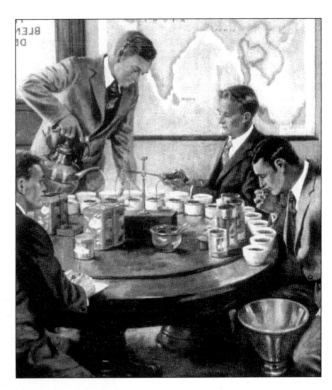

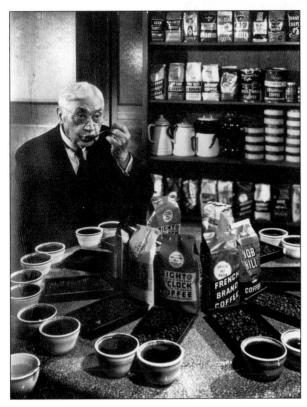

Company legend is that every day George Ludlum Hartford, who never went out to lunch, would go to the tasting department at 2:00 p.m. and have cookies and taste coffee—just to be sure that their product was the best it could be. This photograph was taken c. 1940 at New York City's Graybar Building, where A&P had moved its headquarters in 1927. (Courtesy the Hartford Family Foundation.)

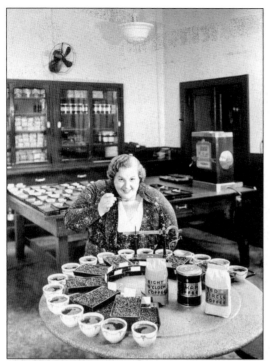

A&P's most notable celebrity spokesperson over the years was Kate Smith. As a popular singer and food enthusiast, her endorsement of A&P coffee and bakery products won fans all over the country. She traveled to store openings and coffee-roasting plants, posing with employees and always smiling for the camera. A weekly radio program featured her vocal talents, and the commercials prompted happy listeners to drink A&P coffee. She is seen here tasting coffee in one of the company's testing departments. (Courtesy the Hartford Family Foundation.)

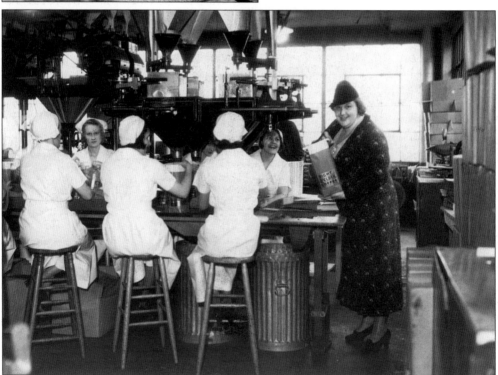

On a national promotional tour for A&P, Kate Smith visits an A&P coffee-roasting plant in Pittsburgh, Pennsylvania. (Photograph by Trinity Court Studio; courtesy the Hartford Family Foundation.)

Another well-known television and movie star, Sid Caesar, poses while drinking a cup of Eight O'Clock coffee at a trade show in the Boston area. Caesar was a personal favorite of John Hartford in the early days of television. (Courtesy the Hartford Family Foundation.)

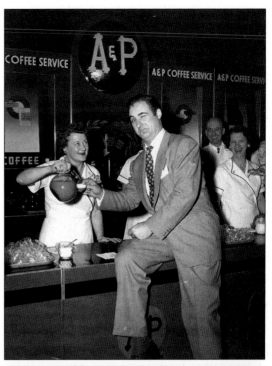

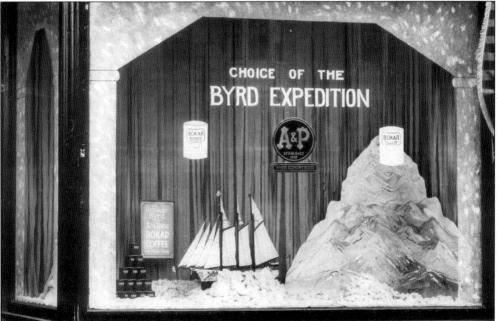

In 1928, this Boston window display featured Richard E. Byrd's expedition to the South Pole. Two and a half tons of Bokar coffee (enough to brew 150,000 cups) and 10,000 pounds of Quaker Maid beans were brought along to feed the 81-man crew for two years. In a subsequent expedition, Bokar coffee that had been buried in the ice on the first trip was retrieved. The coffee was still fresh, prompting advice to customers to refrigerate their coffee at home. (Courtesy the Hartford Family Foundation.)

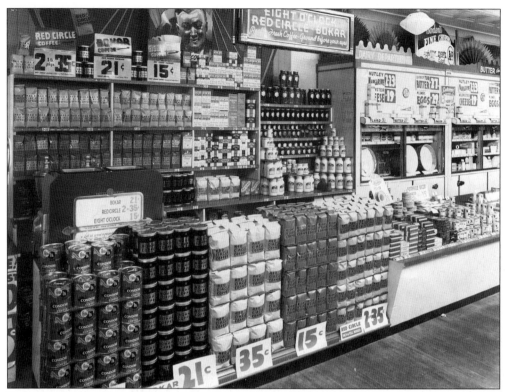

Eight O' Clock coffee was the largest-selling coffee of all brands in the world in the 1930s and 1940s. These A&P coffee displays are typical of those in stores throughout the United States during the 1940s. The one above was located at the A&P store at 193 Bedford Street in Fall River, Massachusetts. (Courtesy the Hartford Family Foundation.)

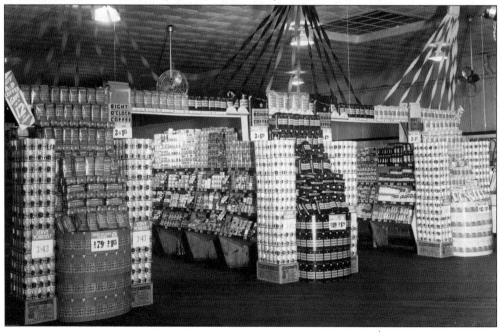

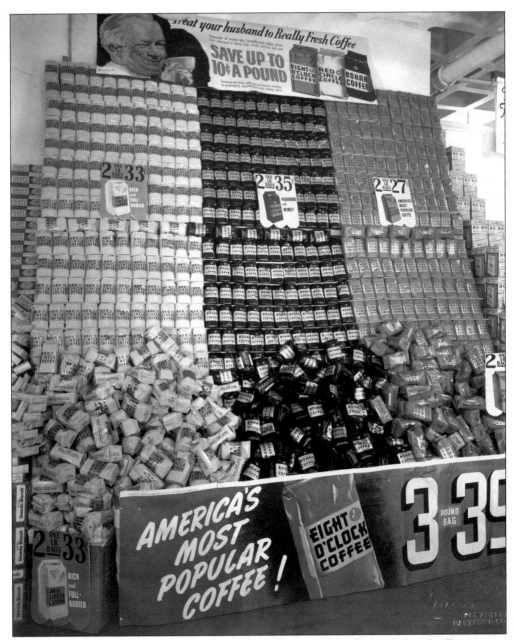

Pictured is a typical in-store display for A&P coffee in 1938. This store, at 491 Farmington Avenue in Hartford, Connecticut, was responsible for selling 1,200 pounds of coffee in a single week. Note that the price of a three-pound bag of coffee was 39¢. The proud store manager was Gaspard Laford, and the superintendent was George F. Lynch. (Photograph by Press; courtesy the A&P Historical Society.)

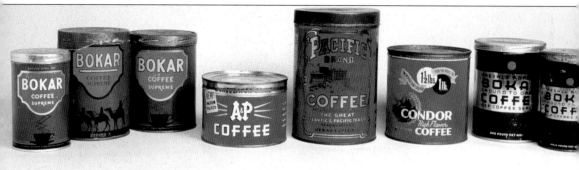

Over the years, A&P sold a variety of coffee products under different brand names. The can designs and names were changed frequently, especially in the early days. Yet, Eight O'Clock has always remained the company's most recognizable brand. For more than 140 years, Eight O'Clock has been America's best-selling whole bean coffee. The aroma of freshly ground coffee was such an important factor in selling Eight O'Clock that store managers in the late 1800s ground the coffee and sprinkled it on the sawdust-covered floors of their stores. (Photograph by Jeff Martin; courtesy the Hartford Family Foundation.)

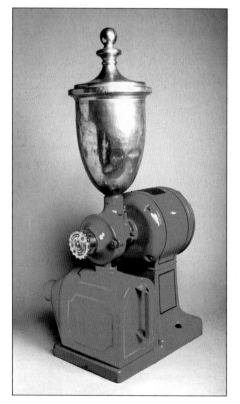

The presence of coffee grinders in every store has provided coffee aromas for customers for more than 100 years. (The Hobart electric coffee grinder, shown here, was a popular store model.) Eight O'Clock used only the finest Arabica beans, which are much better quality than the Robusta beans used in ground coffee. Arabicas grow at high elevations and require cool, dry air as well as adequate sunshine and rainfall. (Photograph by Jeff Martin; courtesy the Hartford Family Foundation.)

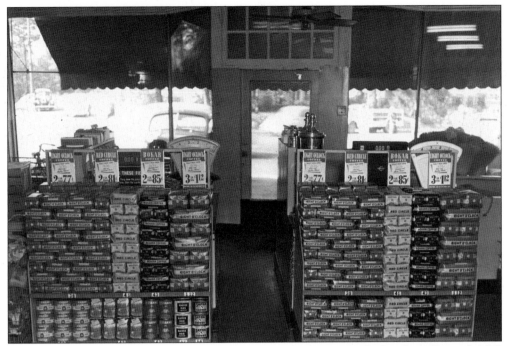

This A&P store was located on Seventh Street in Charlotte, North Carolina. Bags of A&P Bokar coffee are visibly displayed. Bokar was a high-end blend that was steel cut at A&P roasting plants and for many years sold in tins. The photograph was taken in April 1947. (Courtesy the A&P Historical Society.)

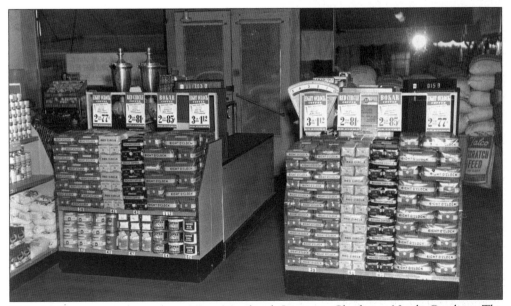

This A&P store was located on West Morehead Street in Charlotte, North Carolina. The photograph was also taken in April 1947. The coffee grinders are visible at each checkout counter. Customers were discouraged from buying more than one week's supply of coffee at a time to ensure its freshness. (Photograph by Whitsett Photograph; courtesy the A&P Historical Society.)

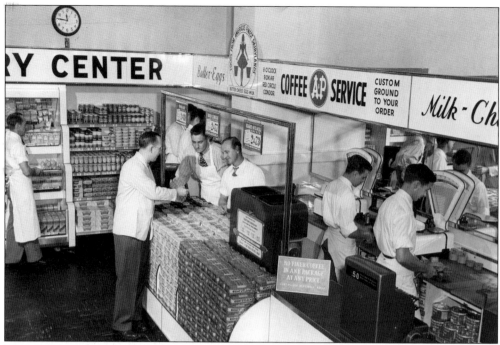

This photograph of the A&P store at 337 Sherman Avenue in Newark, New Jersey, was taken in the late 1940s. (Courtesy the A&P Historical Society.)

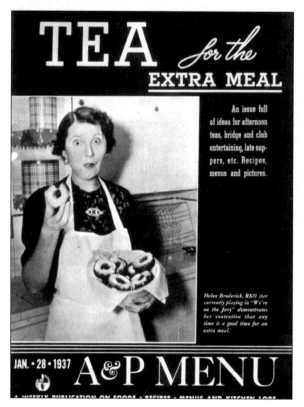

Over the years, A&P's love of coffee did not replace its original loyalty to tea. Our Own Tea was a huge product for A&P for many years, and this copy of the *A&P Menu* for the week of January 28, 1937, presents recipes for food to have with an cup of afternoon tea. The *A&P Menu* was first printed in magazine format and later as a newsletter. It was given out free in the stores and included recipes for every day of the week. Of course, the recipes all featured A&P-produced ingredients. They also offered three different price range recipes so there would be something for housewives of all economic means. (Photograph by Jeff Martin; courtesy the Hartford Family Foundation.)

Six

FROM THE ATLANTIC TO THE PACIFIC

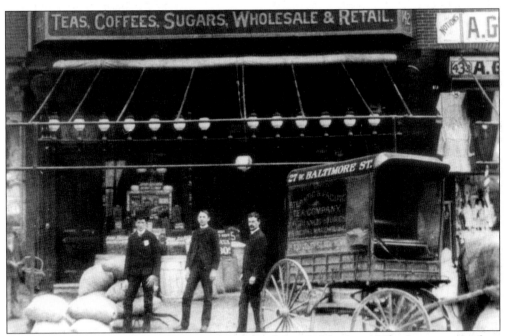

A&P had laid the foundation for streamlined distribution of food in 1859 when a cargo of tea arrived directly from Asia and was moved from the ship's hold to the warehouse and then to Great American wagons, which delivered all over the eastern seaboard. Beginning in the 1880s and continuing through the 1920s, A&P's wagon salesmen covered the eastern United States under the name Great American Tea Company. They sold the company's expanding product line in high-wheeled, red-and-gold carts that were part traveling stores and part premium redemption centers on wheels. This photograph was taken in the late 1880s in front of the A&P store on Baltimore Street in Baltimore, Maryland. (Courtesy the Hartford Family Foundation.)

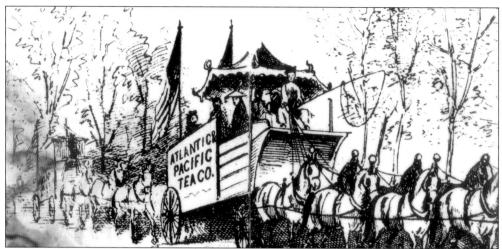

As A&P's door-to-door salesmen began traveling America's back roads, A&P used wagons as marketing tools. The company sent across country, from New York to Chicago, special promotional vehicles through towns where new stores were opening. The red-and-gold, 20-foot wagons with Asian themes were drawn by teams of eight horses in harness spangled with gold plate and saddles surrounded by gold-plated bells. One of the most famous teams, called the *City of Tokyo*, was loaded with fragrant tea chests and featured a pagoda-shaped driver's seat. In each large town, $500 in gold was offered to the citizen who could come nearest to guessing the combined weight of the team, with a grand, national prize of $5,000. (Courtesy the Hartford Family Foundation.)

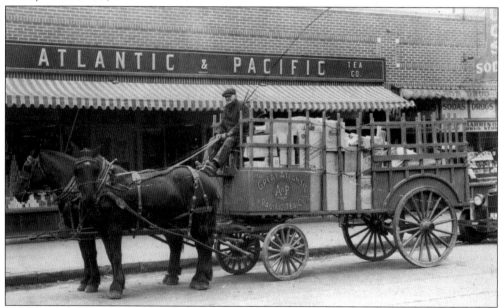

The driver of this delivery wagon is Jesse Mitchell of Davenport, Iowa. He delivered goods daily from the A&P warehouse to seven different stores in the Davenport area, probably around the beginning of the 20th century. Mitchell worked for A&P for seven years. He was born in 1875 and sent this picture to A&P in 1961, when he was 86 years old. Stores were opened rapidly in the Midwest in the late 1800s. By 1885, there were already stores in Chicago and Indianapolis. (Courtesy the Hartford Family Foundation.)

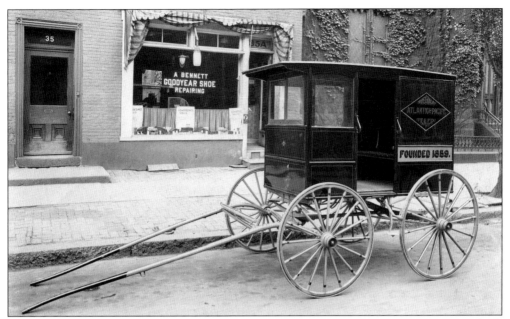

A&P purchased thousands of wagons during the wagon delivery era. This A&P wagon was built by Biehl's Carriage & Wagon Works in Reading, Pennsylvania. It was a No. 405–style wagon. It had $1^1/_8$-inch axles, with three-foot wheels and $1^1/_4$-inch spokes. The body had a loading space that was six feet long and three feet wide. The wagon weighed 850 pounds and had a weight capacity of another 800 pounds. (Courtesy the Hartford Family Foundation.)

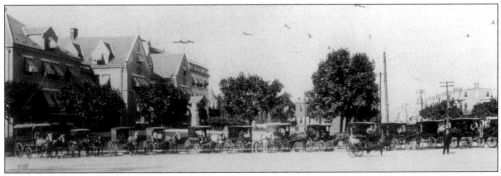

This A&P delivery wagon force covered tea and coffee routes in and around Allentown, Pennsylvania, in 1910. Allentown sales manager J.F. Rasely is standing in the foreground. Still on the job in 1931, Rasely led one of the top-selling field sales forces in the company. (Courtesy the Hartford Family Foundation.)

Many American families in rural areas relied on Great American wagon salesmen for supplies like coffee, cocoa, and cleaning products that they could not obtain locally. They established friendships with the salesmen and looked forward to their weekly visits. Pictured here is the family of Frances Straus of Bridgeport, Ohio. Straus was a customer of the Great American Tea Company for 30 years, and this portrait was featured in a copy of the Great American publication *Tea Talk*. She was serviced by wagon salesman S.T. Blattler of Wheeling, West Virginia. He is shown below with his A&P business partner, Old Black Maud. (Courtesy the Hartford Family Foundation.)

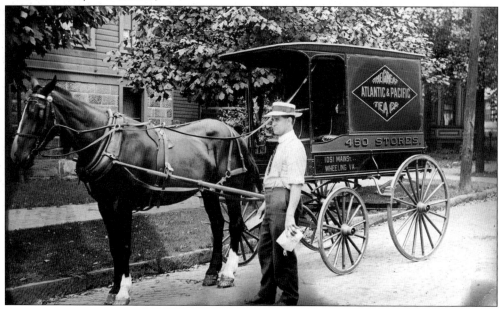

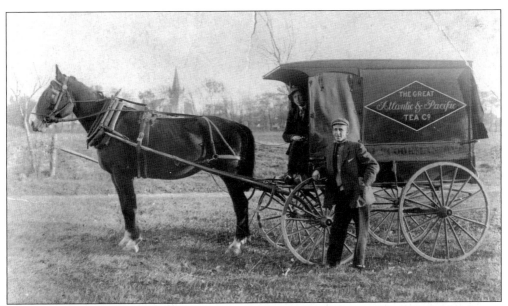

A&P wagon salesman George Reed leans on the wheel of his buggy in Asbury Park, New Jersey. A few years later (below), he is pictured behind the counter of his A&P Economy Store on Main Street in nearby Bradley Beach, New Jersey. (Courtesy the Hartford Family Foundation.)

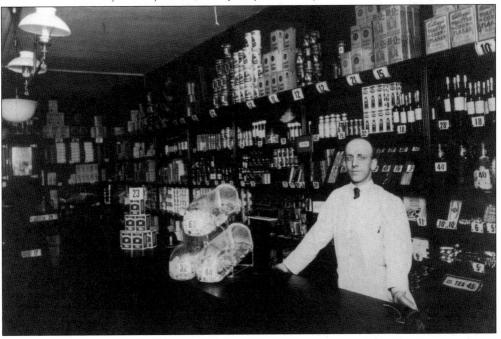

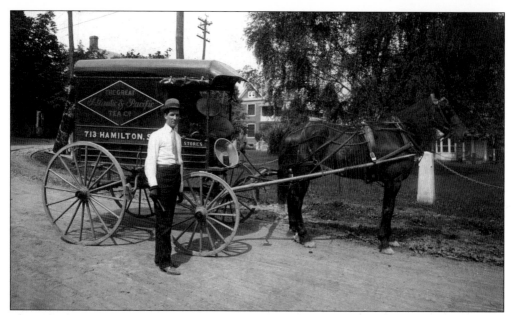

Through the remainder of the 19th century, the door-to-door wagon salesmen were an excellent way for A&P to supplement store locations in rural areas and to introduce people to A&P. By 1910, a large part of the territory of the United States was reached by the high-wheeled red-and-gold wagons, with more than 5,000 established routes. Pictured below is A&P wagon salesman Harry Rhoad, shown "en route to Monroe County" in 1909. The last horse was retired in 1924 when the delivery system was completely converted to trucks. (Courtesy the Hartford Family Foundation.)

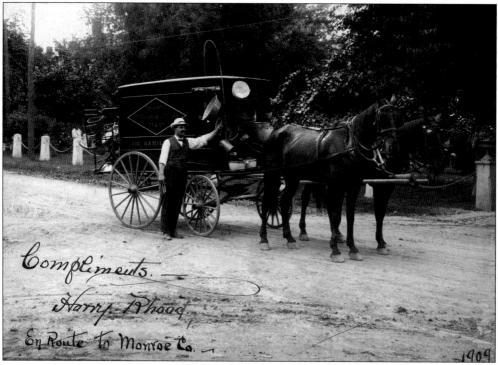

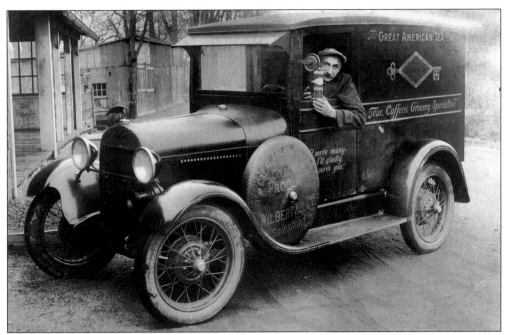

Great American salesman Wilbert Kelly had already worked for the company for 31 years by the time this photograph was taken in 1929. He made the transition from horse and wagon to delivery truck in the early 1920s. (Courtesy the Hartford Family Foundation.)

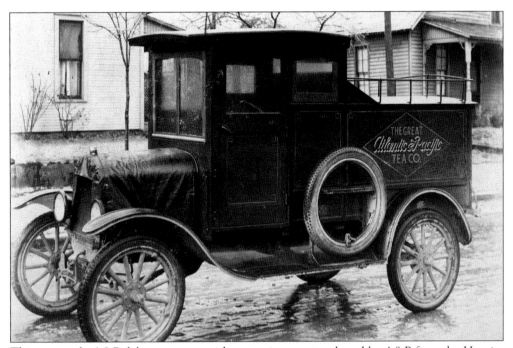

This very early A&P delivery wagon with an engine was purchased by A&P from the Hoosier Cab & Body Company in Middlebury, Indiana, for the staggering price of $114. (Courtesy the Hartford Family Foundation.)

This Great American salesman—F.W. Ohly of Springfield, Ohio, shown next to his sharp delivery vehicle—holds his basket of the latest Golden Key grocery items to show to his customers. Golden Key was one of the brand names given to A&P products sold through the Great American Tea Company. Ohly covered territory operating out of Sandersby, Ohio. Ohly and his associates also sold a line of "Atlantic" products for the home, including baking powder, spices and extracts, cocoa, peanut butter, cereal, and a vast array of "toilet preparations," such as shaving cream, shampoo, cold cream, and dental cream. (Courtesy the Hartford Family Foundation.)

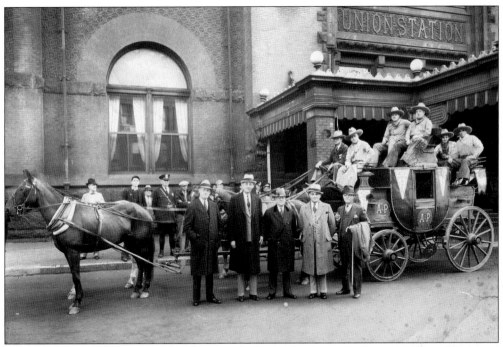

This promotional photograph was taken outside Union Station in St. Louis, Missouri. The event and dignitaries are unidentified, but A&P's flair for promotion is evident with the re-created stagecoach, complete with cowboys. (Courtesy the Hartford Family Foundation.)

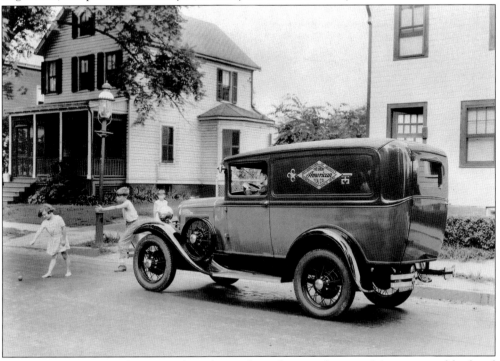

This Great American classic panel truck is making the rounds in an American neighborhood c. 1930. (Courtesy the Hartford Family Foundation.)

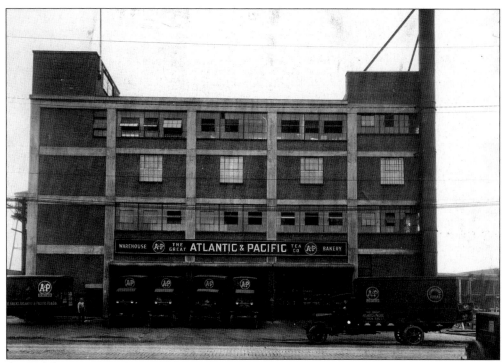

A&P delivery trucks line up in front of a warehouse-bakery facility in Indianapolis. John Lindgren, vice president of the Indianapolis unit (including the above facility), is shown below at the same building with his new car. Lindgren was a career A&P man who was with the company for more than 40 years. (Courtesy the Hartford Family Foundation.)

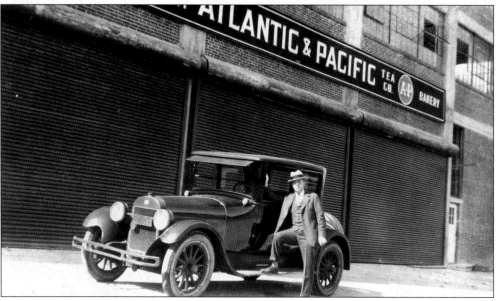

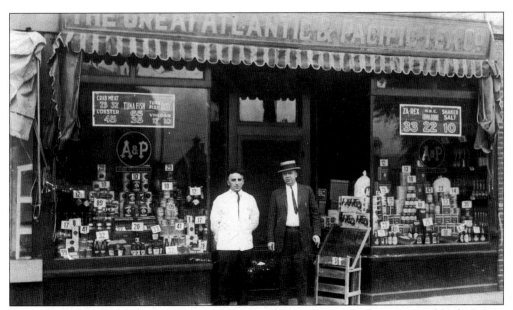

As the vice president of the Indianapolis unit, John Lindgren Jr. was responsible for stores throughout the Indianapolis area. He is shown with a store manager in front of an A&P in downtown Indianapolis. (Courtesy the A&P Historical Society.)

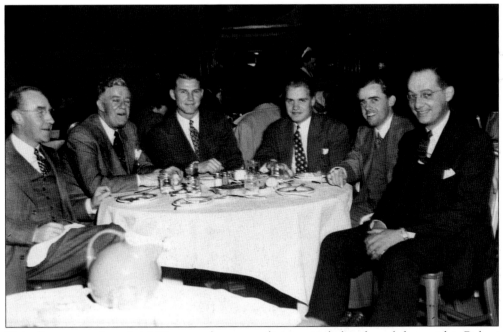

This dinner meeting of A&P's central western division includes, from left to right, Robert Tritten, sales manager, Indianapolis unit; John Lindgren Jr., vice president, Indianapolis unit; Howard Jaehnig, wholesale superintendent, Indianapolis unit; Robert Hoover, bakery sales manager, Indianapolis unit; Robert D. Lindgren, bakery manager, central western division; and Byron Jay, director of sales, central western division. (Courtesy the Hartford Family Foundation.)

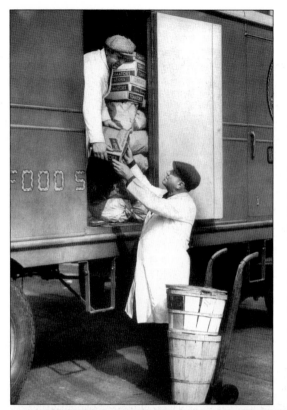

A&P's success was directly attributed to the large quantity of goods sold for the lowest possible price. The enormous quantity allowed the company to undercut the prices of the competition. Goods moving in carload lots paid lower freight charges. Loaded trucks, which delivered their merchandise to one or very few locations, did so for less cost than trucks making many stops. A&P saved about 15 percent on transportation costs by moving large quantities via carloads and truckloads. This rapid transit of goods lowered company costs, and the savings were passed on to the customers. The truck below was leased from Watson Brothers of Washington, D.C., and was probably used to transport produce. (Courtesy the Hartford Family Foundation.)

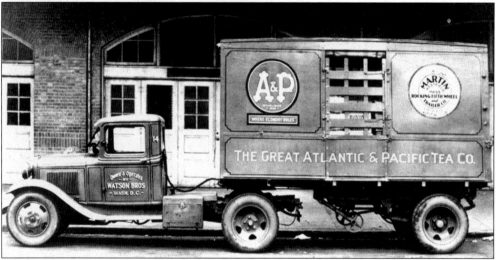

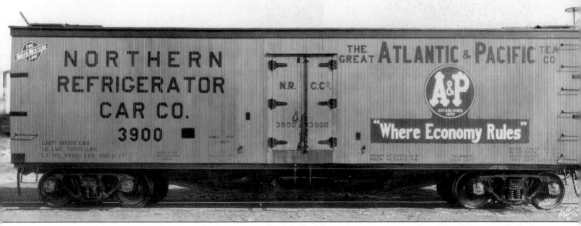

By 1928, A&P spent close to $25 million for railroad transportation of goods. That included 205,164 full carloads of groceries for A&P stores. If those railroad cars were placed end to end, they would make a train over 1,500 miles long and stretch halfway from the Atlantic to the Pacific. This photograph shows an early A&P refrigerated railroad car. (Courtesy the Hartford Family Foundation.)

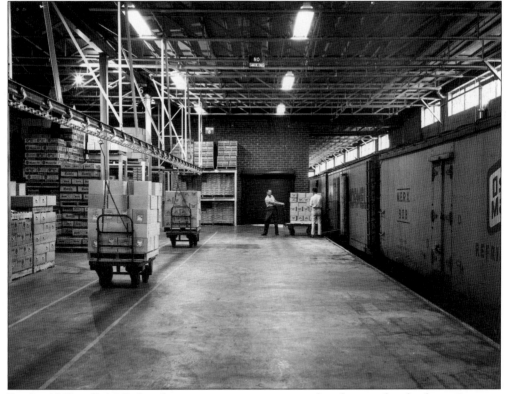

By the 1960s, all A&P distribution centers were equipped with special rail sidings. In many instances, such as the warehouse shown here, the railroad tracks extended right into the buildings to make unloading the rail cars and loading the trucks more efficient. (Courtesy the A&P Historical Society.)

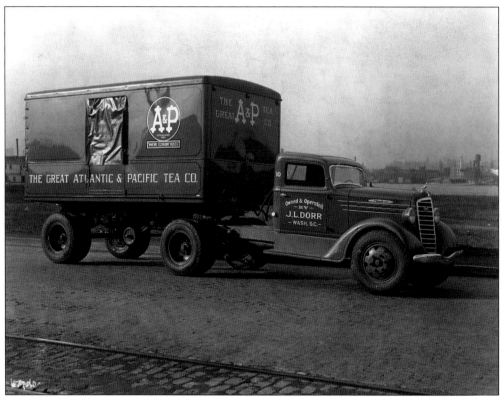

This A&P delivery truck was owned and operated by J.L. Dorr of Washington, D.C. His route was in the Baltimore area in the mid-1930s. (Courtesy the Hartford Family Foundation.)

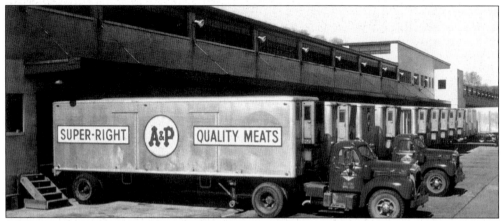

A&P's many warehouses, or distribution centers, were strategically located close to the center of specific distribution areas to reduce the secondary transportation cost to a minimum. In this photograph, A&P trucks are loaded at a distribution center in the New York metropolitan area in the early 1960s. (Courtesy the Hartford Family Foundation.)

Trucks played an increasingly important role in the transport of goods through the 1940s and 1950s. By 1970, the Great Atlantic & Pacific Tea Company had more than 2,400 trucks operated by the company or on its behalf throughout the United States. An advertising campaign boasted that if these trucks were lined up bumper to bumper, they would have created a traffic jam 65 miles long. (Courtesy the A&P Historical Society.)

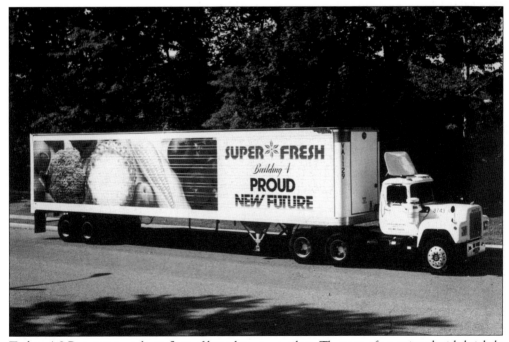

Today, A&P maintains a large fleet of leased tractor trailers. They are often painted with brightly colored fruits and vegetables or bags of Eight O'Clock coffee. This Super Fresh truck from the late 1980s features some extra-large vegetables. (Courtesy the Hartford Family Foundation.)

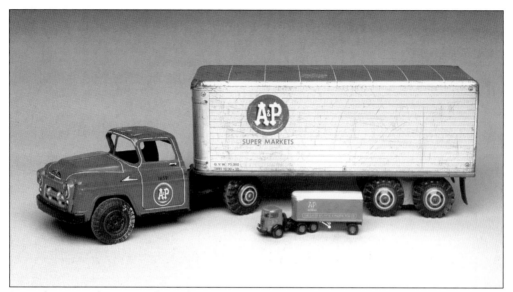

Reproductions of A&P trucks and trains are very collectible in today's antiques market. This large truck is a classic toy from 1959 purchased from an antique dealer, and the small truck is a reproduction built for A&P in 1997 by toy manufacturer Hartoy Inc. (Photograph by Jeff Martin; courtesy the Hartford Family Foundation.)

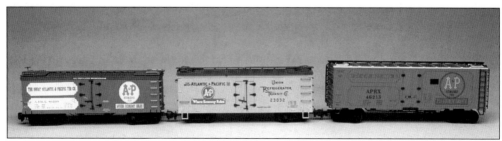

These model boxcars give an accurate picture of early A&P graphics. (Photograph by Jeff Martin; courtesy the Hartford Family Foundation.)

Seven

PRIVATE MANUFACTURING

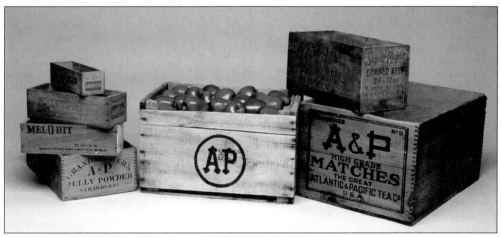

The early success of the Great American Tea Company was accomplished by selling a limited number of products to an increasingly expanding customer base. Tea, coffee, baking powder, and spices were the mainstay goods in the first few stores. By the 1920s, A&P had become a worldwide organization, purchasing tea in India, coffee in Brazil, butter from Midwestern dairies, and salmon from Alaskan fisheries. What the company could not buy at a reasonable price it began producing. Soon, the company opened Quaker Maid factories, which produced canned goods and other pantry staples. A&P's Nakat Packing Corporation caught and canned its own salmon, and regional Jane Parker Bakeries provided fresh breads and cakes to A&P stores everywhere. As the product line diversified, goods were shipped by truck and railroad car in wooden crates and boxes like the ones shown here. The boxes were used to transport such items as fruit, bread, jelly, cheese, corned beef, and boxed matches. (Photograph by Jeff Martin; courtesy the Hartford Family Foundation.)

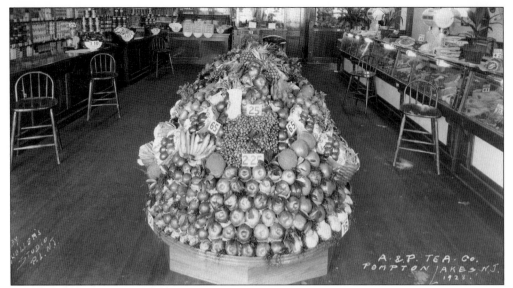

By 1925, A&P stores were bigger and much more diversified in their product offering. Stores began selling produce and an expanded line of dairy items. A study of consumer likes and dislikes found many comments requesting fresh meats. By 1929, some 3,000 meat departments had been installed in A&P outlets, moving the company from the Economy Store period to the era of the combination stores. The groceries are neatly shelved and the fruit artistically arranged in this 1928 A&P store in Pompton Lakes, New Jersey. (Photograph by Mueller's Studio; courtesy the A&P Historical Society.)

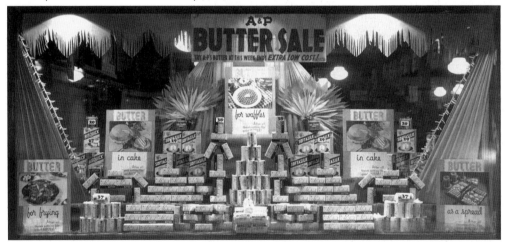

When A&P manufacturing began under the name Quaker Maid, the company conducted a study of its customers' food likes and dislikes to determine what its factories should be producing. The study indicated that New Englanders ate most of the corned beef in the United States. They also preferred yellow corn and brown eggs, and they liked wider, fatter bacon than most other Americans. A&P also found that Philadelphians ate more dried prunes and ice cream than any other city in the country. Study findings reported that the people of Scranton, Pennsylvania, bought more butter per capita than any other city. In 1931, A&P was the largest butter retailer in the world, selling more than 130 million pounds annually. To encourage butter's popularity in Indianapolis in the early 1930s, this store window boasted a big sale. (Photograph by Hirshburg; courtesy the A&P Historical Society.)

Americans began purchasing an increasing amount of staples at A&P stores. This cartoon by A&P customer Donald Ragsdale of Rome, Georgia, expresses his opinion that America was getting its money's worth at the country's A&P stores. The cartoon was originally printed in the *A&P Tattle Tale* magazine in August 1923.

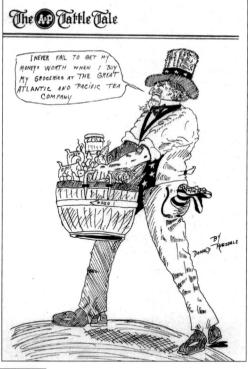

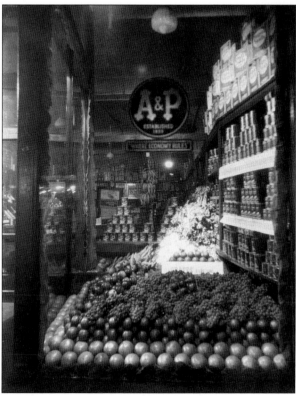

In 1925, the Atlantic Commission Company was established by A&P as a wholly owned subsidiary. The Atlantic Commission pioneered mass distribution of fresh fruits and vegetables on a company-wide basis. This made it possible for consumers to get reasonably priced, farm-fresh, out-of-season produce on almost a year-round basis for the first time in history. This attractively arranged produce encouraged customers to buy their fresh foods at A&P. Pictured in the mid-1920s, the store was located in Schuylkill Haven, Pennsylvania. (Courtesy the Hartford Family Foundation.)

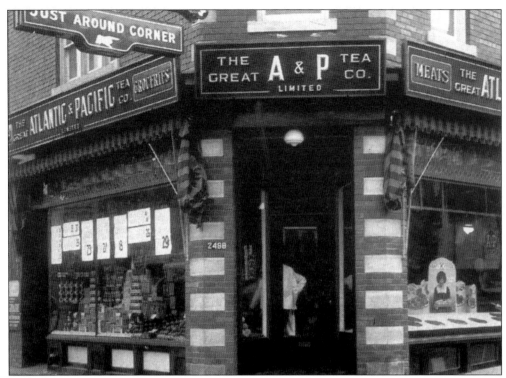

The rise of the combination stores continued into the 1930s, with more than 3,000 stores established in the United States and Canada. A&P entered the Canadian market, establishing its first store in Montreal in May 1927, and rapidly opened an estimated 125 stores by August 1928. This store, located on Yonge Street, was the first A&P opened in Toronto in April 1928. By the end of that year, the company had opened 30 stores in this city. (Courtesy the Great Atlantic & Pacific Tea Company Inc.)

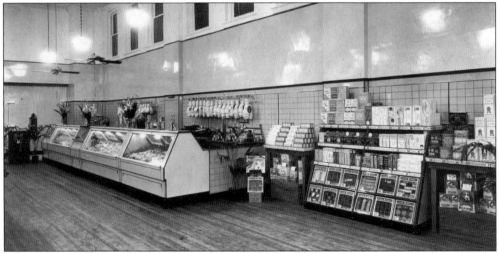

A&P's combination stores were located in the best retail shopping sections of America's cities. They offered fresh fruits, candy, bakery items, delicatessen products, and fresh meats. The location of this store is unidentified, but its variety of products is very evident. (Courtesy the A&P Historical Society.)

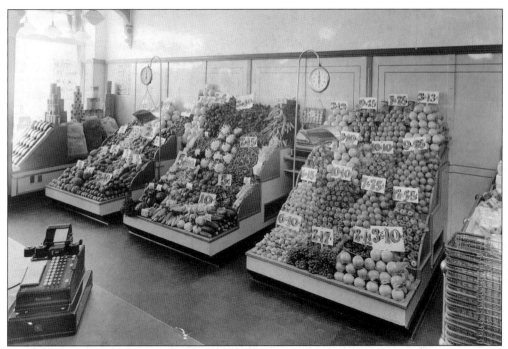

A&P managers' manuals of the 1930s and 1940s stressed the importance of visually attractive displays. It is a wonder that a piece of fruit could be removed from any of these displays without causing an avalanche of citrus. The photograph above was taken in 1936, and the store was located on Rockaway Boulevard in Queens, New York. The A&P produce department below was located in a store on McKinley Avenue in Dallas, Texas. It was photographed by Frank Rogers & Son in 1946. (Courtesy the A&P Historical Society.)

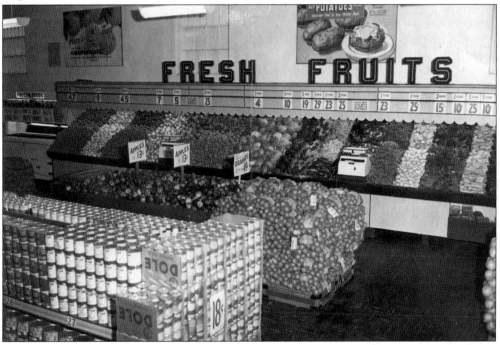

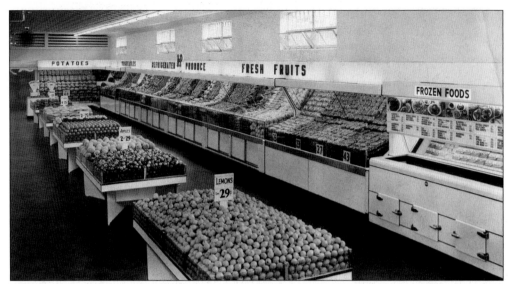

This photograph of an expanded produce department was taken in 1947 at the A&P store at 221 Commerce Place in Greensboro, North Carolina. The store's focus on self-service was evident in the wide aisles and generous selection. (Courtesy the A&P Historical Society.)

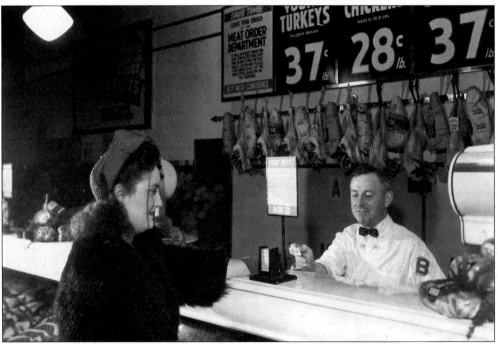

The National Meat Department of the A&P operated out of Chicago in order to be closer to the Black Angus and Hereford cattle breeders of the western states. Meat was purchased from a packer and delivered to one of the company's warehouses, where it was cut into rounds, chucks, loins, and ribs. It was rarely kept in the warehouse for more than a day before the cuts were reloaded on refrigerator railroad cars or trucks and delivered to stores. This woman is purchasing meat at the butcher's counter in the A&P at 661 Amsterdam Avenue in New York City in 1942. (Photograph by the Drucker Hilbert Company; courtesy the A&P Historical Society.)

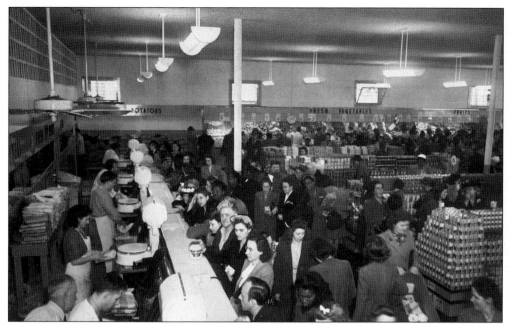

Although A&P was not the innovator of the supermarket concept, the company was quick to begin opening them around the country. Real estate was hard to come by because the war made new construction difficult, and larger stores were not easy to lease. Some of the early supermarkets were housed in converted automobile showrooms. This supermarket grand opening took place in an A&P on Asheboro Street in Greensboro, North Carolina, on April 11, 1946. Considering the crowded aisles in both photographs, it was obviously quite a happening in town that day. (Courtesy the A&P Historical Society.)

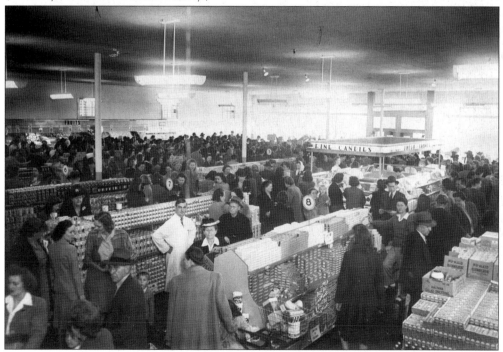

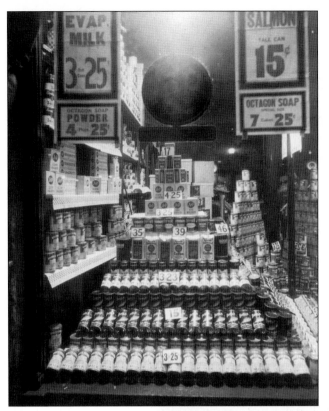

Salmon is advertised in this Schuylkill Haven, Pennsylvania store for 15¢ a can. By 1930, of all Alaskan salmon sold in the United States—10 percent, or 24 million cans—was bought in A&P stores. More than half of that was made up of salmon from A&P's own canneries under the Nakat Packing Corporation. The company established its own canneries in Alaska in order to provide quality salmon for its customers at reasonable prices. (Courtesy the A&P Historical Society.)

Pictured is an advertisement for A&P canned salmon from the cover of a 1923 A&P Tattle Tale magazine. (Courtesy the Hartford Family Foundation.)

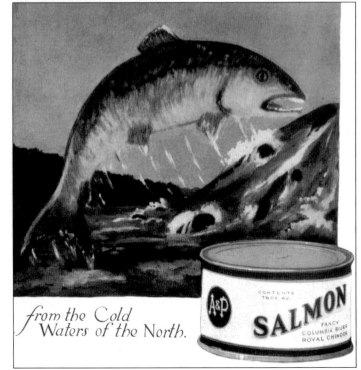

96

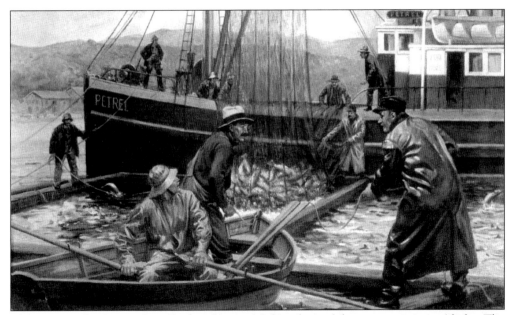

This painting by Anton Otto Fischer depicts A&P's salmon-fishing operations in Alaska. The artist, Anton Otto Fischer, was commissioned by A&P to paint a series of advertisements for the company. He became quite a well-known artist in later years. The painting is in the collection of the Great Atlantic & Pacific Tea Company.

Fresh fish was added to A&P butcher departments in the 1940s. This in-store A&P fish market was located in a store at 410 Hillsborough Street in Raleigh, North Carolina, in 1946. Pictured is W.W. Ferrell, the store's meat and fish manager. (Courtesy the A&P Historical Society.)

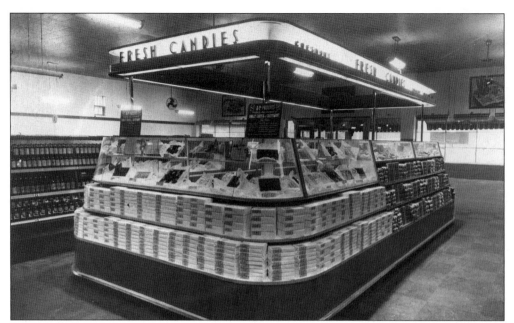

Candy was first sold in A&P stores in the 1920s. The stores stocked bar candy, gumdrops, and cream drops, which were shipped in bulk from the warehouse and sold to the customer in paper bags. By 1960, Quaker Maid candy factories were making assorted chocolates, hard candy, lollipops, gum candy, marshmallows, and peanut candy. This was the first candy counter in an A&P store in the South, at the corner of 11th and North Streets in Charlotte, North Carolina. (Courtesy the A&P Historical Society.)

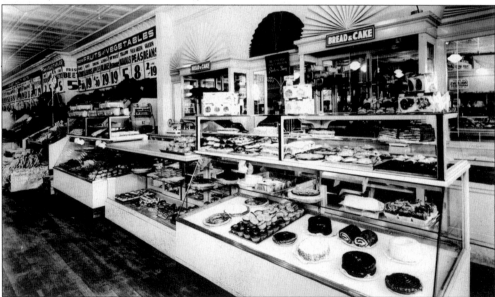

A&P began baking its own bread as early as 1917. By the late 1920s, A&P was selling 600 million loaves of bread a year. A one-pound loaf retailed for 5¢, and a one-and-a-half-pound loaf for 7¢. Thirty large A&P bakeries around the country produced white, raisin, rye, and whole wheat bread and doughnuts in huge quantities daily. On average, 153,700 loaves of bread were sold every hour of the business day across A&P counters. (Courtesy the A&P Historical Society.)

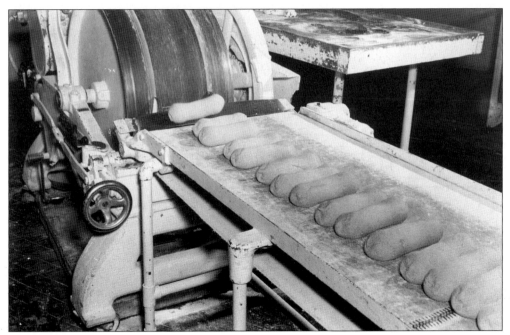

Over the years, three trade names of A&P's loaves of bread were popular: Grandmother's, Marvel, and Jane Parker. This 1930s bread machine is producing loaves at the Jane Parker Bakery in Philadelphia, Pennsylvania. (Courtesy Walt Waholek.)

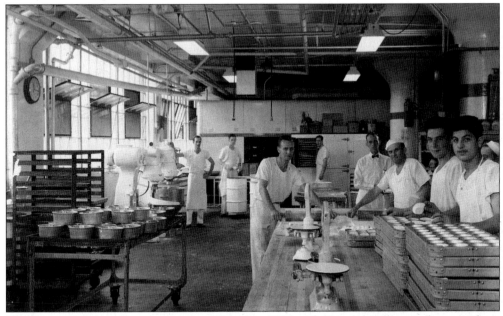

The National Bakery Division was established in 1939 with Howard Gilb as its first president. For the next 25 years, the bakeries contributed approximately 50 percent of A&P's net profit. The division operated 35 bakeries in the United States and two in Canada. This was the first Jane Parker Bakery in A&P's central western division. It opened in 1943 in Detroit, Michigan. The man with the bow tie in the center of the photograph is John Rentz, a lifelong employee of A&P. (Courtesy the Hartford Family Foundation.)

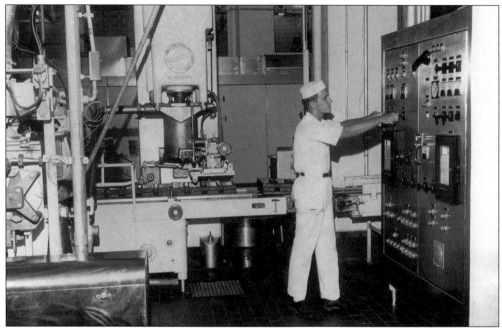

Bakery products were strictly tested, and samples from all Jane Parker bakeries were sent to the A&P experimental bakery. Loaves of bread were tested for freshness, volume, crust color, symmetry, evenness of bake, crust character, grain, crumb color, aroma, taste, mastication, and texture. In this 1967 photograph, A&P baker Sid Williams adjusts the oven temperatures in the Jane Parker Bakery in Charlotte, North Carolina, to make sure his bread comes out just right. (Courtesy the Hartford Family Foundation.)

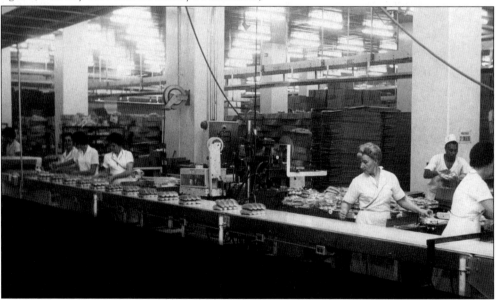

By 1960, A&P bakeries produced 23 varieties of breads, 5 kinds of doughnuts, 40 types of cakes, 42 varieties of sweet rolls and coffee cakes, 15 kinds of pies, and 11 types of rolls. These employees are packaging an all-American staple, hot dog rolls, in a Jane Parker Bakery in the 1960s. (Photograph by Jerry Overman; courtesy the Hartford Family Foundation.)

Eight

THE 1950S AND 1960S

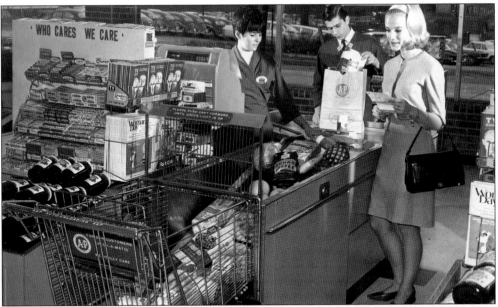

The 1950s marked the end of the Hartford family's management of A&P. John Hartford died suddenly at the age of 79 on September 20, 1951. President Ralph Burger assumed full command, with octogenarian George L. Hartford still providing guidance to employees, who affectionately referred to him as Mr. George. It was a new era, and many changes needed to be made to keep A&P in the forefront of the American retail business. New strategies were established, and by the late 1960s, A&P was the grocery industry leader with $5.4 billion in sales, well over $1 billion ahead of the nearest chain competitor, Safeway. During the 1950s and 1960s, new innovations were stressed, such as the automatic unloading wagons pictured here. (Courtesy the A&P Historical Society.)

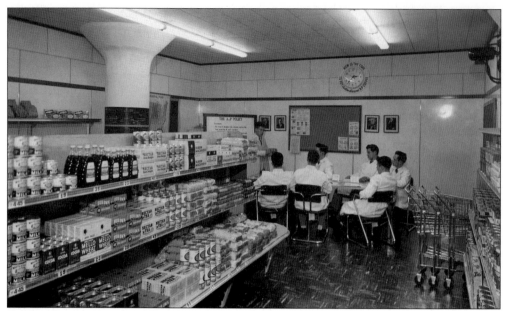

During the late 1940s and 1950s, A&P management focused on employee training. The company established regional training centers and taught recently hired employees new proficiencies in bakery management, butcher skills, marketing, and checkout operations. The class above is learning management techniques at a training program in Pittsburgh. Employee training for store checkers took place at A&P Checker School (below) at the Graybar Building in New York City. (Above courtesy the Hartford Family Foundation. Below photograph by Albin Heinrichs; courtesy the A&P Historical Society.)

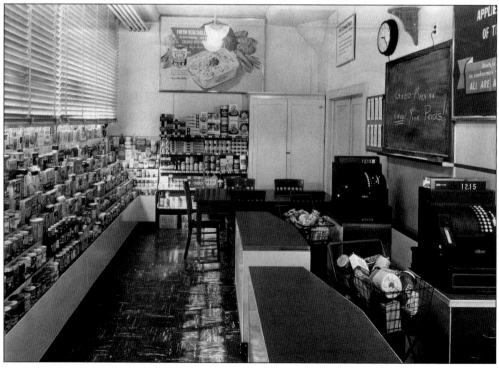

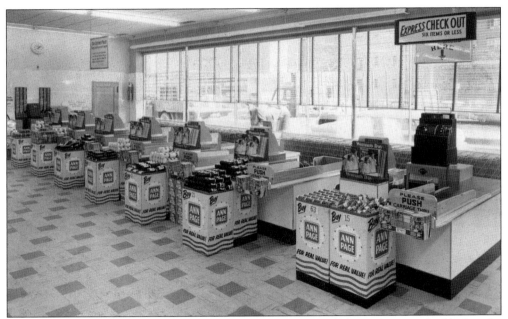

Checker trainee graduates arranged these perfect A&P store counters, photographed before the store's grand opening on November 29, 1958. It was located at 249 First Avenue in New York City. (Courtesy the A&P Historical Society.)

This A&P store, located at 956 Second Avenue in New York City, is shown in the fall of 1957. Just a few blocks over, at A&P's Graybar Building headquarters, the company was mourning the loss of the last of the founding Hartfords. George L. Hartford died on September 24 at the age of 94, having spent over 70 years working for his "little family business." (Photograph by Camera Associates; courtesy the A&P Historical Society.)

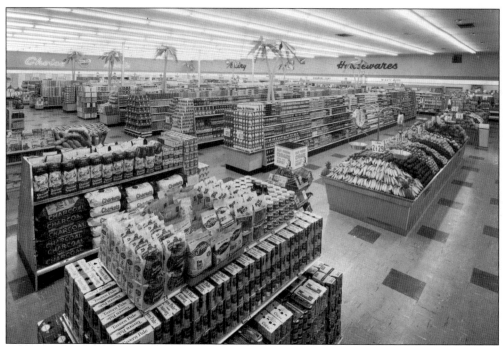

This 1957 A&P store was located clear across the country in Pasadena, California. Note how the palm trees contributed to the store's decor. Unfortunately, George Huntington Hartford's dream of operating stores throughout the United States, from the Atlantic to the Pacific, did not continue into the future. Poor sales and strong independent competition forced A&P's withdrawal from California in the late 1960s. (Photograph by J. Allen Hawkins; courtesy the Hartford Family Foundation.)

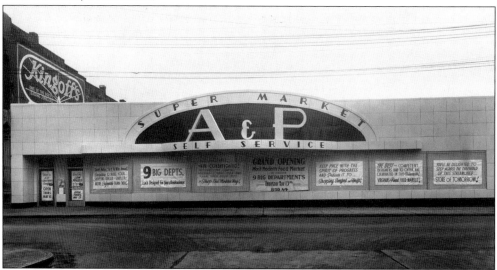

A&P's sales for 1958 surpassed the $3 billion mark for the first time. The net profit after taxes was $53.9 million. Sales and profits continued to rise satisfactorily for a few years as A&P stepped up its store remodeling program. This unusual storefront with its rarely seen logo, located in Roanoke, Virginia, was soon to be replaced by an early American-style store. (Photograph by the Parker Studio; courtesy the A&P Historical Society.)

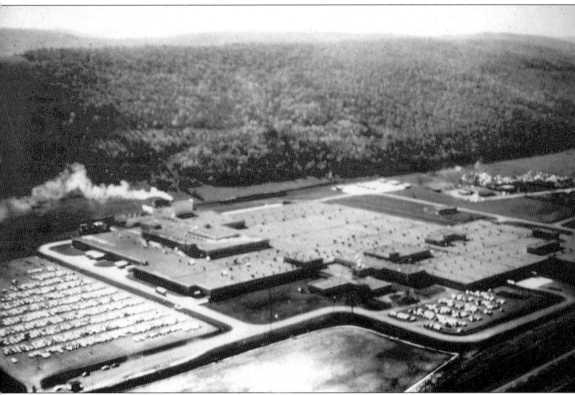

Completed in 1965, this one-and-a-half-million-square-foot Ann Page manufacturing plant in Horseheads, New York, cost the company $25 million. At the time, it was the world's largest manufacturing and processing facility under one roof. The facility also included a development laboratory and a pilot plant for the study of new products. (Courtesy Walt Waholek.)

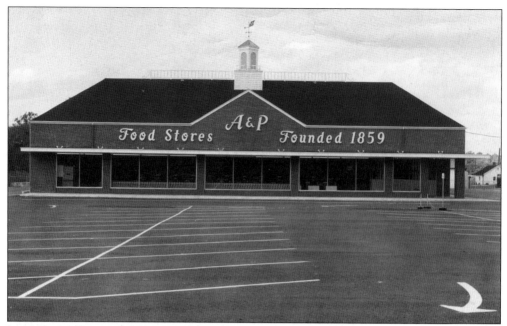

In 1960, A&P opened 255 new stores and remodeled 510 old stores. At that time, there were 4,351 A&P stores in 37 states; Washington, D.C.; and Canada. This store, located in Westwood, New Jersey, is shown before its opening in 1965. (Photograph by Albin Heinrichs; courtesy the A&P Historical Society.)

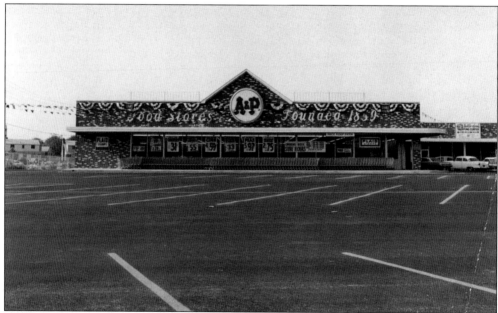

This A&P supermarket grand opening took place in Garden City, New York, on June 2, 1964. Note that plaid stamps are prominently advertised. The promotional practice of giving away trading stamps with purchases was reinstated by A&P in 1961, with the E.F. MacDonald Company providing the stamps. (Photograph by Platnick Photographs; courtesy the A&P Historical Society.)

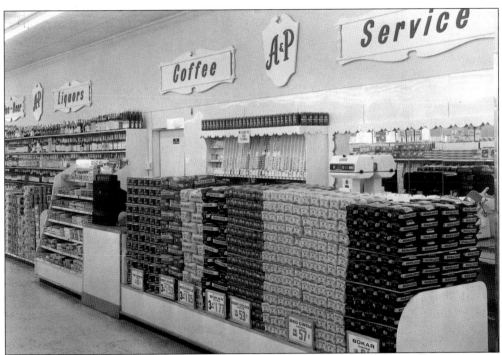

A&P introduced the colonial stores in the late 1950s and continued building and remodeling in that style through the 1960s. The A&P coffee display above probably dates from the late 1960s, with signage in the early American style of the times. The photograph was taken in a supermarket on Route 23 in Franklin, New Jersey. The structural architecture of the period's newly remodeled stores featured a colonial design similar to the one seen below, with its characteristic cupola and weathervane. (Above photograph by Albin Heinrichs; courtesy the A&P Historical Society. Below courtesy the A&P Historical Society.)

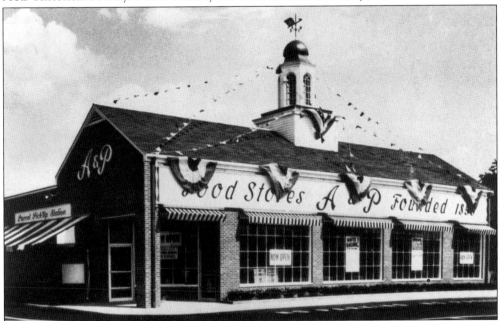

This image served as the cover of the 1966 A&P annual report. It shows a "satisfied customer," aided by a "next generation shopper" in a "modern A&P supermarket." The A&P national brands that shoppers purchased at that time were Ann Page, Jane Parker, Super-Right, Cap'N John's, Eight O'Clock, Red Circle, and Bokar. (Courtesy the Hartford Family Foundation.)

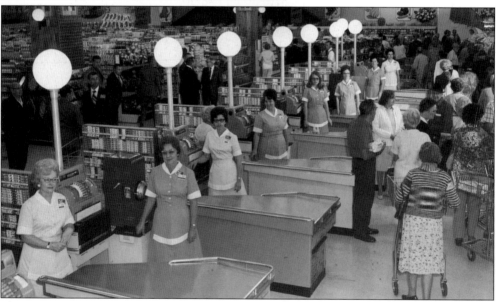

This A&P grand opening took place in Evansville, Illinois, on September 30, 1970. In true 1960s style, the store checkers were wearing alternating pastel uniforms and the checkout counters were alternately turquoise and yellow. Cigarettes dominated every checkout station, long before supermarkets began keeping them under lock and key. (Photograph by Greenwell Photography; courtesy the Hartford Family Foundation.)

Nine
THE HAUB ERA

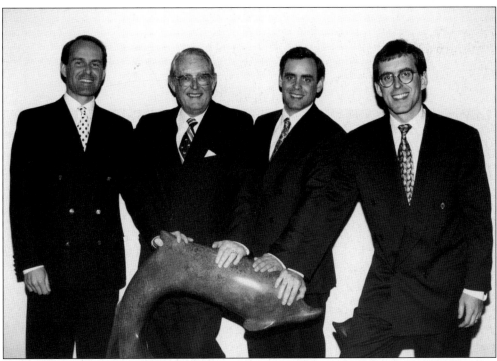

Today, the chief executive officer and majority shareholders of A&P represent a family with a history similar to that of the Hartfords. In Germany, the Wilhelm Schmitz-Scholl Company, manufacturers of sweets, chocolates, and candies, was founded by the forefathers of Erivan Haub in 1867, just eight years after George Huntington Hartford founded the Great American Tea Company. Erivan Haub—chairman of the Tengelmann Group, the majority shareholder of A&P—is the father of Christian Haub, chief executive officer of the company today. This photograph shows Erivan Haub with his three sons. From left to right are Karl-Erivan Haub, Erivan Haub, Georg Haub, and Christian Haub. (Courtesy the Tengelmann Group.)

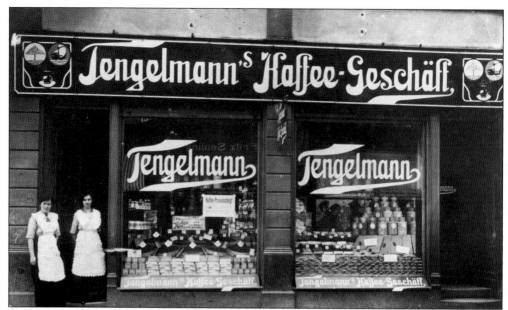

In 1893, Erivan Haub's predecessors established their first specialty food stores, called Tengelmann Kaffee-Geschaft, trading mainly in coffee, tea, cocoa, and chocolates. The banner was named for Emil Tengelmann, the company's chief clerk and authorized signatory in the early days. Pictured here is a storefront in Offenbach, Germany, *c.* 1907. (Courtesy the Tengelmann Group.)

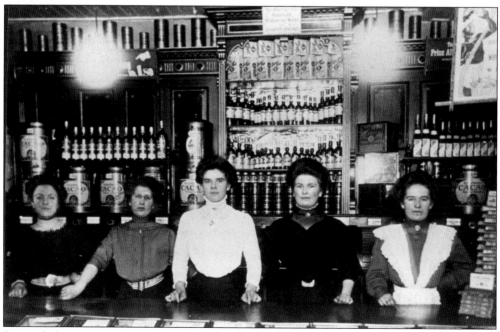

Store clerks pose in a Tengelmann Kaffee-Geschaft unit in 1900. By 1914, the chain had expanded throughout Germany, growing to 560 outlets. After 1910, the store banner was shortened to the single name, Tengelmann. (Courtesy the Tengelmann Group.)

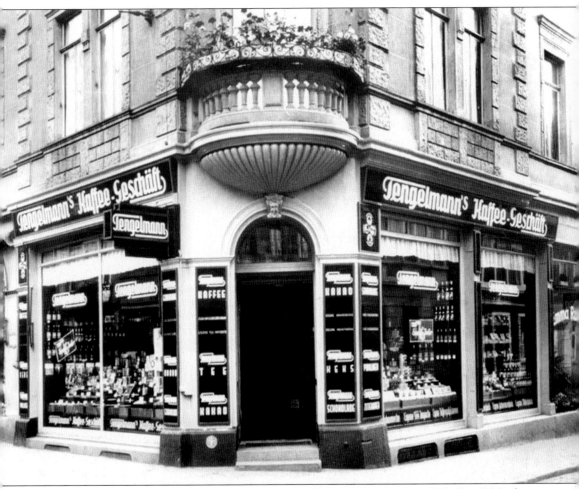

This Tengelmann store occupied a corner in Heidelberg, Germany, in 1930. By 1980, the Tengelmann Group operated more than 2,000 stores in Europe, including supermarkets and discount stores. (Courtesy the Tengelmann Group.)

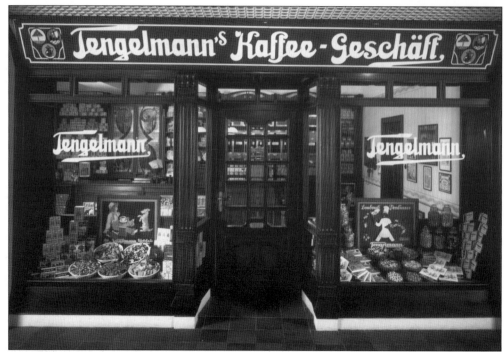

In 1995, the Tengelmann Group built a museum at its headquarters to celebrate the company's rich and prosperous heritage. Located in Mulheim an Der Ruhr, Germany, the museum's entrance has been designed to re-create an early store exterior. (Courtesy the Tengelmann Group.)

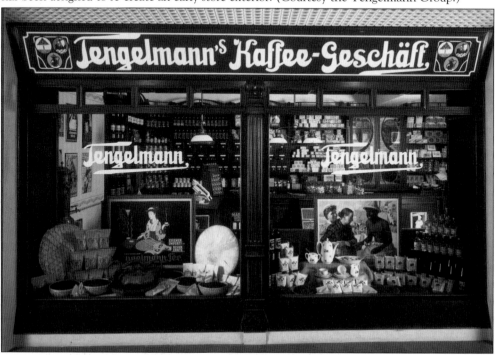

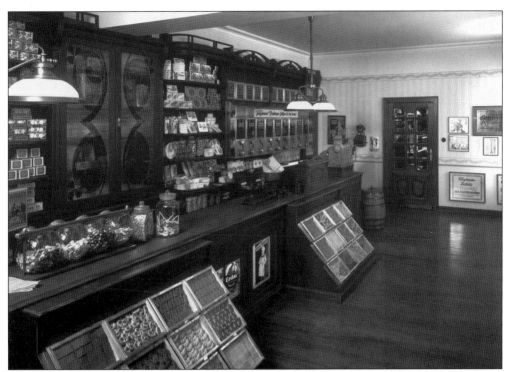

These photographs were taken inside the Tengelmann Museum in Mulheim, Germany. Although the museum is not open to the general public, it serves as an information center for Tengelmann employees and for visitors to the company. (Courtesy the Tengelmann Group.)

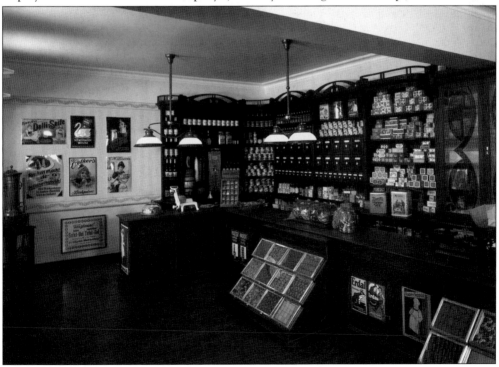

Today, more than 100 products are marketed for the German Tengelmann stores bearing the A&P label. They include paper towels, cookies, coffee, tea, pasta, canned frankfurters, rice, and deviled ham. On the German corporate banner, the "A&P" stands for *attraktiv und preiswert*, attractive and low-priced. (Above photograph by Jeff Martin; courtesy the Hartford Family Foundation. Below courtesy the Tengelmann Group.)

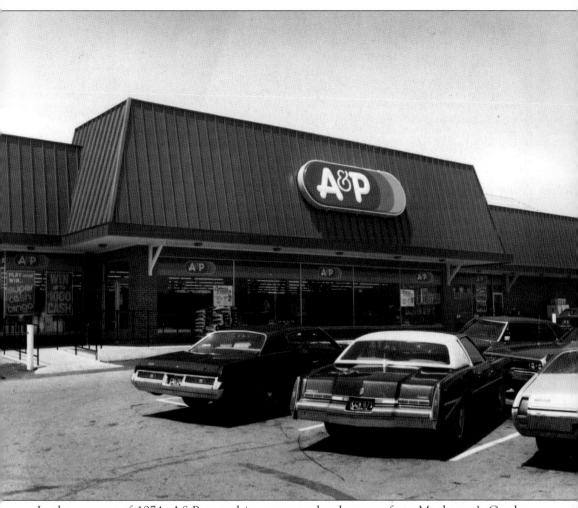

In the summer of 1974, A&P moved its corporate headquarters from Manhattan's Graybar Building to a large complex in suburban Montvale, New Jersey. In 1979, after more than a decade of decline, Hartford family members and the John A. Hartford Foundation sold the majority of A&P shares to the Tengelmann Group. In 1980, the new board of directors elected James Wood (previously CEO of the Grand Union Company) as chairman, president, and chief executive officer of A&P. Within three years, the new management exited several markets, closing hundreds of stores and the majority of its manufacturing operations, including the Horseheads, New York facility (shown on page 105). In 1982, the reorganized, smaller A&P, operating fewer than 1,000 stores, returned to profitability. Pictured here is a typical A&P of the late 1970s, this one in Kentucky, one of the markets eventually exited by the company. (Courtesy the A&P Historical Society.)

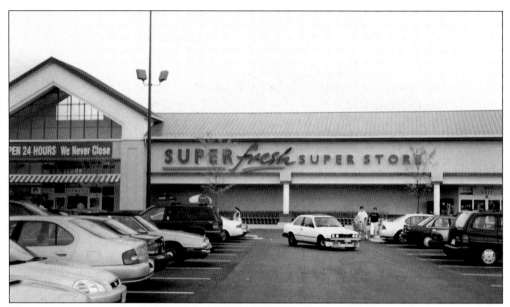

In 1982, the company launched the Super Fresh banner in A&P's previous Philadelphia division. Emphasizing product freshness and strong customer service, the banner expanded outward from Philadelphia. Today, the company operates more than 90 Super Fresh stores in New Jersey, Maryland, Pennsylvania, Delaware, Virginia, and the District of Columbia. Shown here is the Timonium, Maryland store, which consumers voted as "Baltimore's Best" in a 1999 survey by *Baltimore Magazine*. (Courtesy the Great Atlantic & Pacific Tea Company Inc.)

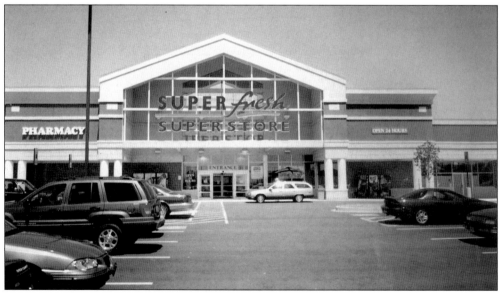

In a 2000 *Baltimore Magazine* survey, this Super Fresh in Ellicott City, Maryland, was named the best place to shop in the state. The store was also cited as employer of the year by the state of Maryland. (Courtesy the Great Atlantic & Pacific Tea Company Inc.)

A&P acquired Wisconsin-based Kohl's Food Stores in October 1983. Max Kohl and his family were pioneers in the retail food industry in Milwaukee, opening their first store in 1927. Through years of steady and well-planned growth, Milwaukee soon became dotted with buildings bearing the familiar Kohl's name. The first modern self-service Kohl's supermarket opened in Milwaukee in 1946 and is still in operation today. In the 1970s, Kohl's expanded into the Green Bay, Madison, and Racine areas. This 1970s Kohl's was located in Brookfield, Wisconsin. (Courtesy the Great Atlantic & Pacific Tea Company Inc.)

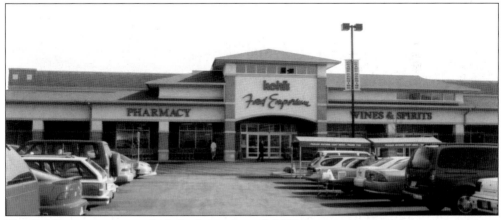

The Kohl's acquisition marked the beginning of A&P management's growth via acquisition strategy and the first such purchase in company history. The Kohl's chain also included a group of department stores that the Kohl family continues to own and operate. Today, A&P's Midwest region, based in Detroit, operates 138 stores, including Farmer Jack supermarkets in Michigan, and 33 Kohl's stores in and around Milwaukee, Wisconsin. This Kohl's store is located on University Avenue in Madison. (Courtesy the Great Atlantic & Pacific Tea Company Inc.)

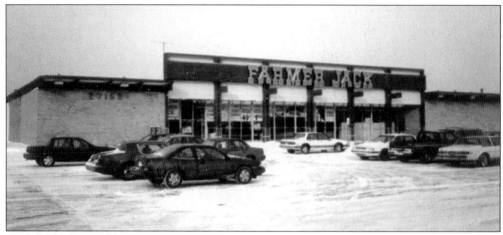

The chain that would eventually become Farmer Jack was founded in 1927 by Tom Borman, who opened his first grocery store at Forest and 12th Street on Detroit's west side. Later, Al Borman joined his brother, and the two gradually expanded the business over the next three decades. Between 1956 and 1964, the Borman family doubled the chain from 26 to 52 stores, operating under the Food Fair banner. In April 1965, the company opened its first Farmer Jack store in Detroit, combining an emphasis on fresh produce with the existing grocery business. Its success led to the conversion of the entire chain to the Farmer Jack format and banner. By 1980, the company had expanded to 81 stores. Pictured is a typical example of the early Farmer Jack stores. (Courtesy the Great Atlantic & Pacific Tea Company Inc.)

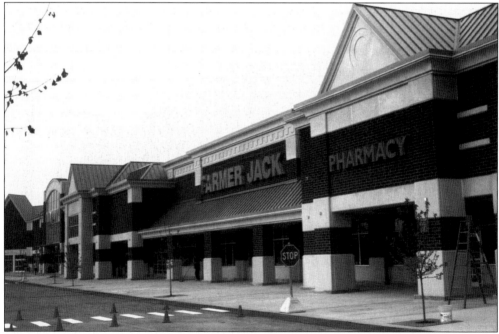

In 1989, A&P acquired the Farmer Jack chain from Borman's Inc. Today, the company operates 110 Farmer Jack supermarkets, ranging in size from 40,000 to 60,000 square feet. The store shown here is located at 1237 North Coolidge Highway in suburban Troy, Michigan. (Courtesy the Great Atlantic & Pacific Tea Company Inc.)

118

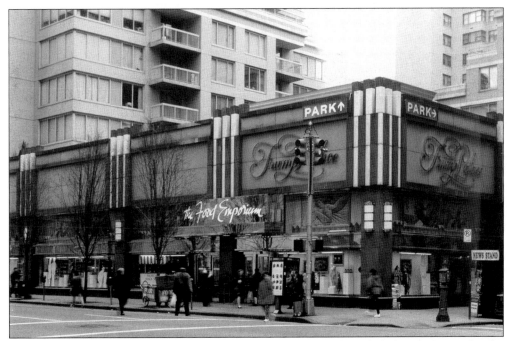

In 1986, A&P acquired the Bronx-based Shopwell Inc., which included 26 stores under the Food Emporium banner. Today, the Food Emporium operates 37 upscale stores in Manhattan and its surrounding suburbs, offering customers the freshest foods, unique specialty items, and restaurant-quality takeout dishes. The Food Emporium shown here is located at 68th Street and Third Avenue, at the Trump Palace in New York City. (Courtesy the Great Atlantic & Pacific Tea Company Inc.)

In 2000, the Food Emporium opened its unique Bridgemarket store, located at 59th Street and Second Avenue beneath the Queensborough Bridge in New York City. The grand opening marked the culmination of a decade-long development project by the management of A&P and the Food Emporium, in cooperation with federal, state, and local government. (Courtesy the Great Atlantic & Pacific Tea Company Inc.)

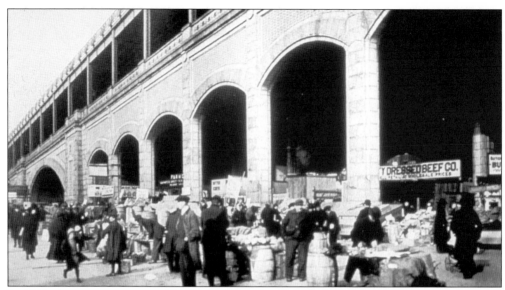

In 1912, the area now occupied by the Bridgemarket Food Emporium was the site of one of New York's famous open-air markets, as shown above. In enclosing the space and fashioning the new store, the architects and builders were required to preserve the original vaulted ceilings, tiled arches, and classic stonework. The transformation of the space was accomplished in conjunction with the New York City Landmarks Preservation Commission, the New York State Economic Development Corporation, the U.S. Department of Transportation, and other agencies. Below is a present-day look at the Bridgmarket store. (Courtesy the Great Atlantic & Pacific Tea Company Inc.)

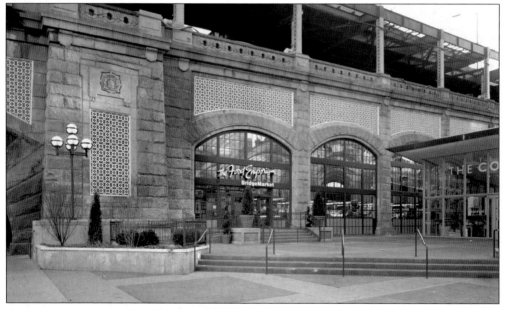

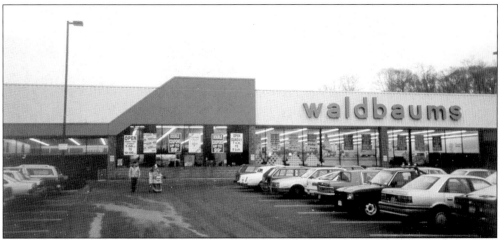

In the fall of 1986, A&P further expanded its market presence in New York with the acquisition of Waldbaum Inc. Nearly 40 years before, Israel Waldbaum had turned over his small grocery stores to son Ira, who masterminded the growth of the business over the next several decades. The company went public in 1962 and expanded into New York's suburbs, most notably on Long Island and, by an acquisition in 1970, to Connecticut and Massachusetts. By 1985, the chain had grown to employ some 7,500 people. This photograph was taken in the 1970s. (Courtesy the Great Atlantic & Pacific Tea Company Inc.)

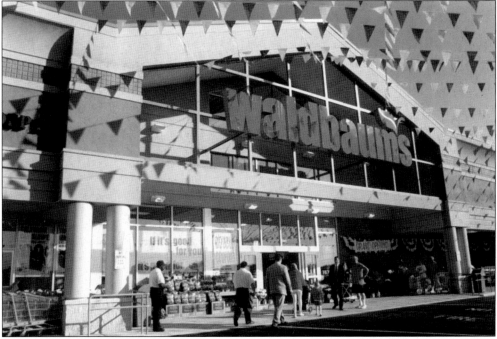

Today, A&P operates nearly 80 Waldbaum's supermarkets in New York's outer boroughs and on Long Island. Waldbaum's continues to uphold its reputation for ethnic and specialty merchandising and outstanding in-store bakeries and delicatessens. The store shown here is located in East Setauket, New York. (Courtesy the Great Atlantic & Pacific Tea Company Inc.)

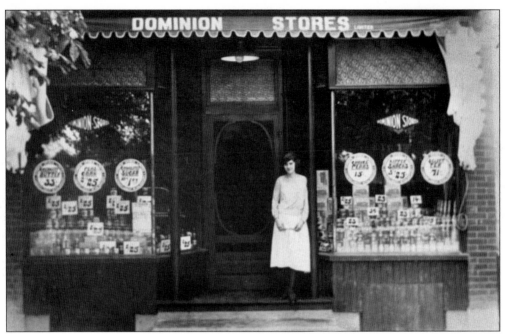

The Dominion banner was established in Ontario, Canada, in 1919. The store shown here was located in the Willowdale section of Toronto. The building, owned by Robert Thompson, was rented to Dominion in the early 1920s for $40 per month. Standing in the doorway is store manager Gertrude Thompson, believed to be the first woman manager of a Dominion store. (Courtesy the Great Atlantic & Pacific Tea Company Inc.)

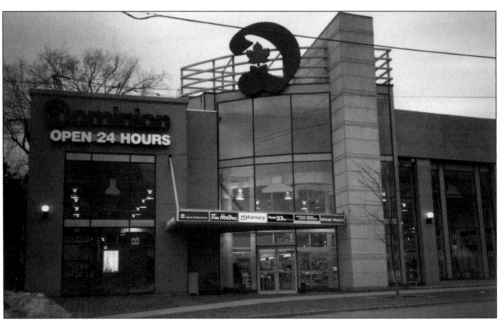

A&P Canada acquired 92 Dominion stores, two warehouses, and an office complex in 1985. This store is located at 5383 Yonge Street in Toronto. (Courtesy the Great Atlantic & Pacific Tea Company Inc.)

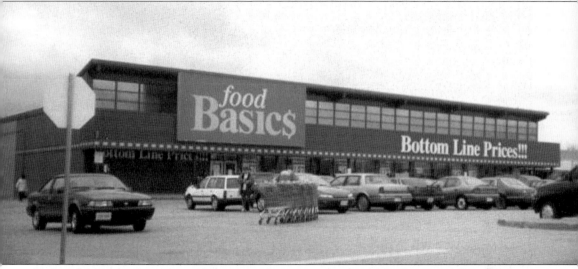

Today, A&P Canada operates 180 stores in Ontario under the A&P, Dominion, Barn Market, and Ultra Food & Drug banners. The company also franchises and supplies 64 Food Basics stores. Shown above is a Canadian A&P Food Basics. Below is a Barn Market store. (Courtesy the Great Atlantic & Pacific Tea Company Inc.)

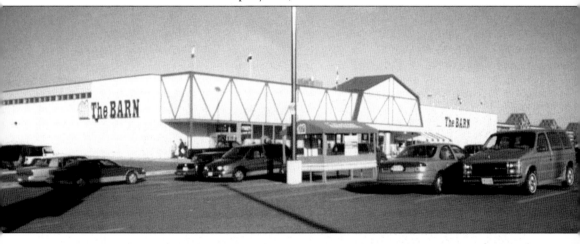

In 1994, A&P launched a new private-label marketing program, replacing the banner-specific labels previously sold through A&P and each of its subsidiaries. The new program consisted of four brands: America's Choice, Master Choice, Health Pride, and Savings Plus. They encompassed all significant grocery and general merchandise categories. America's Choice items were marketed as equals of national brand products at a lower price. Master Choice lines included more upscale and gourmet food items. Savings Plus targeted the most price-conscious consumer, and Health Pride offered savings on high-quality over-the-counter drug products and healthcare items. An array of A&P's private label offerings is shown above. Below are the four brand logos. (Courtesy the Great Atlantic & Pacific Tea Company Inc.)

The famous A&P logo assumed a prominent place high above New York City's Times Square when the company sponsored this electronic advertisement. "We Built a Proud New Feeling" was the company's slogan throughout the 1980s. (Courtesy the Hartford Family Foundation.)

A&P used this painting by Chad Calhoun on the cover of its holiday card for 2001. It is part of Calhoun's "Little Bit of America" series and represents the company's pride in its American heritage. An A&P employee, Calhoun serves as senior art director in the creative services department at A&P's Montvale headquarters. (Courtesy the Great Atlantic & Pacific Tea Company Inc.)

Today, under Christian Haub's direction, A&P is renewing its tradition of leadership. Building from within through its people, with new opportunities, education, technology, and performance standards, the company is ushering in a new era of market leadership and innovation—establishing A&P and its affiliated banners as "the Supermarket of Choice, Where People Choose to Work, Choose to Shop and Choose to Invest." (Courtesy the Great Atlantic & Pacific Tea Company Inc.)

BIBLIOGRAPHY

The following reference materials were used by the author to obtain facts and impressions of A&P's 143-year history:

All About People: The Changing Face of A&P. A&P Canada, 1999.
Annual reports of the Great Atlantic & Pacific Tea Company, 1960, 1961, 1962, 1965, 1966, 1968, 1976, 1979, 1983, 1984, 1985, 1987, 1992, 1994, 1998, and 1999.
A&P: An Organization and Its Workers. The Great Atlantic & Pacific Tea Company, 1930.
A&P Circle. The Great Atlantic & Pacific Tea Company, April–June, 1959.
A&P Circle. The Great Atlantic & Pacific Tea Company, July–September, 1959.
A&P Circle. The Great Atlantic & Pacific Tea Company, October–December, 1959.
A&P Tattle Tale. The Great Atlantic & Pacific Tea Company, January and August 1923.
Chain Store Age, December 1977.
Fortune. "Biggest Family Business," March 1933.
Merchandising Fresh Fruits & Vegetables. The Great Atlantic & Pacific Tea Company, 1947.
Progressive Grocer. "A&P: Past, Present and Future," 1971.
Progressive Grocer, February 1970.
Red Pepper. The Great Atlantic & Pacific Tea Company, January 1931.
Supermarket News, December 1994.
The Greatest Good: The History of the John A. Hartford Foundation. Danbar Press, 1984.
Three Score Years and Ten. The Great Atlantic & Pacific Tea Company, 1929.
Time. "Red Circle and Gold Leaf," November 13, 1950.